PERTH

THEN AND NOW®

AUTHOR ACKNOWLEDGMENTS
A book like this could not be produced without the help of
a great many people behind the scenes and I would like to
particularly thank the ever friendly staff at the State Library
of Western Australia and the Perth History Centre, who always
answer my 'need to know yesterday' questions promptly and
efficiently. Thanks also go to the Royal Western Australian
Historical Society for allowing me access to their unique
collections and, last but not least, to the City of Perth and
board of Heritage Perth, without whose encouragement and
support I would not have been able to immerse myself in the
amazing history of this beautiful city for the last 10 years.

PICTURE CREDITS

Then Photographs:
All photographs are courtesy of the State Library of Western
Australia, except for those on the following pages: 48, 68, 72
(courtesy of the Royal Western Australian Historical Society),
80 (courtesy of the Aviation Heritage Museum of WA).

Now Photographs:
All photographs were taken by David Watts with the exception
of those on the following pages: 113 (Getty Images).

PERTH

THEN AND NOW®

RICHARD OFFEN

PAVILION

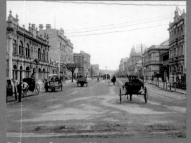

St Georges Terrace, 1905 p. 8

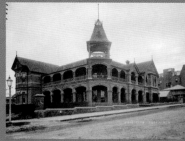

The Weld Club, c. 1893 p. 14

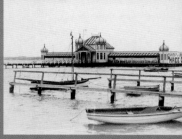

Perth City Baths, 1899 p. 18

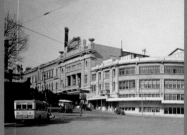

Capitol Theatre, 1930 p. 22

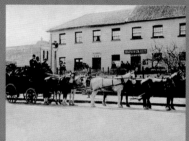

Freemason's Hotel, c. 1890 p. 24

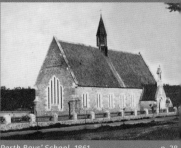

Perth Boys' School, 1861 p. 28

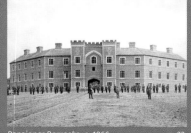

Pensioner Barracks, c. 1866 p. 32

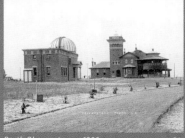

Perth Observatory, c.1900 p. 34

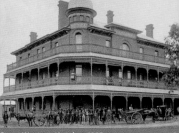

Great Western Hotel, c. 1897 p. 42

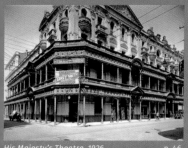

His Majesty's Theatre, 1926

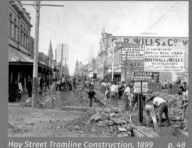

Hay Street Tramline Construction, 1899

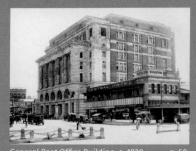

General Post Office Building, c. 1930

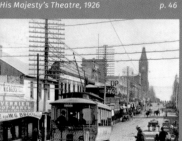

Barrack Street, 1901

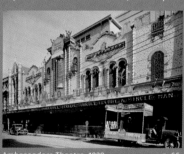

Ambassadors Theatre, 1929

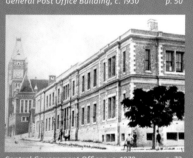

Central Government Offices, c. 1879

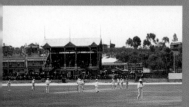

The WACA, c. 1905

St. George's Hall, c. 1890

Cottesloe Beach, 1920

'The Swan River would require the language of a poet to describe it. The scenery on its banks is lovely beyond description; its course is beautifully serpentine.' So wrote one correspondent in a letter to the *Glasgow Courier* sent from HMS *Sulphur*, moored in Cockburn Sound, in September 1829.

Sadly, for the settlers who formed the Swan River Colony in the winter of 1829, it was soon discovered that the vast river floodplain was nothing more than a huge and agriculturally useless sand dune. Such were the many and severe hardships suffered by those early settlers that one of their number, Eliza Shaw, was moved to suggest, 'The man who declared this country good deserves hanging nine times over.'

The beauty and usefulness of the river on which Perth now stands has been recognised for many millennia. Archaeological evidence shows that Aboriginal people have been using the Swan River and its surrounds as an important source of food for at least 40,000 years. As a result, the area also became an important cultural meeting place for the Whadjuk Noongar people, who have gathered here for many thousands of years.

Although Europeans had known about the west coast of Australia for several centuries, early expeditions had claimed only the eastern half of the continent. After making a first unsteady British foothold on the southern coast in Albany, in 1827 Captain James Stirling was despatched to explore the west coast for a suitable settlement. Having spent 12 days exploring the Swan River area, he was beguiled by its beauty and misled by the lushness of the flora into believing it was similar to the most fertile parts of Italy. Seeing only the possibilities and the prospects for new settlement, the foundations of Perth were laid.

Named after the birthplace of Lord Murray, the British Parliament's Colonial Secretary, Perth gradually took shape

PERTH
THEN AND NOW INTRODUCTION

as a town despite the problems of sourcing suitable building materials. This meant that many were still sleeping in tents long after the declaration of the township. In addition to the sparsity of agricultural land, two other problems hampered progress. One was an acute lack of labour to build roads and bridges; the other was a severe shortage of capital investment. After a considerable amount of political lobbying, and much to the surprise of those intended as their gaolers, the first convicts arrived in June 1850 – the irony being that the ship carrying the first cargo of convicts had overtaken the one carrying the British Government message confirming its approval for transportation to start.

This influx of labour, some of it skilled, soon transformed Perth and helped build public buildings such as the Town Hall, the first Colonial School and Government House. With the convicts came experienced professionals, employed to oversee the projects undertaken by them. One was Richard Roach Jewell, the first trained architect in the colony, who has left us a legacy of many elegant buildings, the principal ones of which appear in the pages of this book.

By 1856, when Perth was declared a city by Queen Victoria, its physical and social shape had largely been determined. The administrative, political and business centre was based around St Georges Terrace; Hay and Murray Streets developed as a commercial and shopping precinct; while further west around Kings Street and also in East Perth, artisans' workshops, cottages and stockyards were to be found.

Still vital for communications was the river. A port was developed at the southern end of William Street, providing a trading link with the sea port at Fremantle and the agricultural community of the Swan Valley at Guildford. Economic activity at this time was still based on agriculture, with wool a primary export for many years, aided by exploiting newly found resources such as sandalwood. Income was scarce, however, and the colony struggled to make its mark

until the end of the 19th century when Western Australia struck gold and the first resource boom began.

With the 1890s discovery of gold in the Murchison and Eastern Goldfields, Perth witnessed a massive influx of population and wealth. The gold rush brought about a transformation from modest country town to prosperous commercial city, demonstrated by the grandeur of the former Land Titles Building, the graceful lines of the McNess Royal Arcade and the opulence of His Majesty's Theatre, all erected to demonstrate Perth's status as a significant gold city.

In 1901 Federation transformed Western Australia from an independent colony to a State of the Commonwealth of Australia, and Perth gained the status of capital city for the new state. During the 1920s the appearance and character of Perth was confirmed rather than altered, although late in the 1930s the construction of several multi-storey buildings in the city centre, such as the Gledden, CMLA and Commonwealth Bank buildings, were a portent of the dramatic changes the city would undergo in the last 40 years of the 20th century.

The population of Perth changed in size and character after World War II as immigration brought new cultures and traditions to the city. A major phase of development spurred on by further resource booms of the 1960s, 70s and 80s saw skyscrapers built and the city take on a more modern character, sometimes in ways which we would now have cause to question. During the entrepreneurial 1980s and more temperate 1990s, the city continued its transition from a Victorian gold town into a dynamic and progressive city.

From very humble and difficult beginnings, Perth has evolved into an exciting and beautiful cosmopolitan city, full of evidence of its past and promises for its future. This book charts some of that evolution, reveals the layers created by the city's progress, and touches on some of the characters who have made Perth the bewitching place it is today.

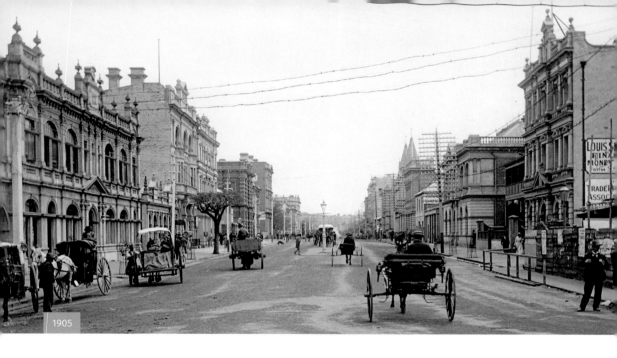

1905

ST GEORGES TERRACE
The fashionable residential and business area of town

ABOVE: This street was initially called 'King George's Terrace', after King George IV, but by the time the English geographer John Arrowsmith drew a map of the town in 1833, it was being referred to as 'St George's Terrace', probably being renamed after the king's death in 1830. To ensure standards were maintained, a regulation was passed in 1833, which stipulated that only homes costing at least £200 could be built on this street and it became a fashionable residential and business area of the town.

Various improvements to the street were carried out in the 1870s and 80s, including levelling and the addition of a footpath, but it was the new-found gold wealth of the 1890s that changed the architecture of the street out of all recognition and removed most of the residential properties. On the immediate left of the photograph stands the United Services Hotel and on the right is Weld Chambers, containing the Trade Protection Association.

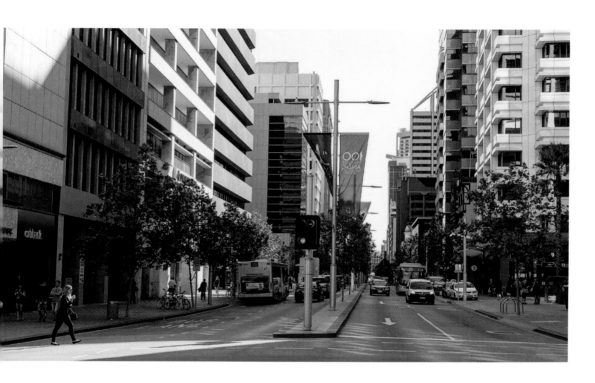

ABOVE: Following the first gold boom and during the Great Depression of the 1930s, few changes were made to the late 19th-century elegance of 'the Terrace' (as it is locally known), but the Western Australian mineral boom, which started after World War II, was to change all that. A need for a significant increase in office accommodation, coupled with an internationally held disregard for the significance of 19th-century architecture, brought about the disappearance of buildings which today would be considered important examples of their time. The United Services Hotel was replaced in the early 1970s by the Suncorp building and Weld Chambers made way for the St Martins Centre in 1978. At about the same time, the street name also lost its apostrophe. While the 19th-century charm of the western end of the street has disappeared, the area has retained the bustling atmosphere of a busy central business district.

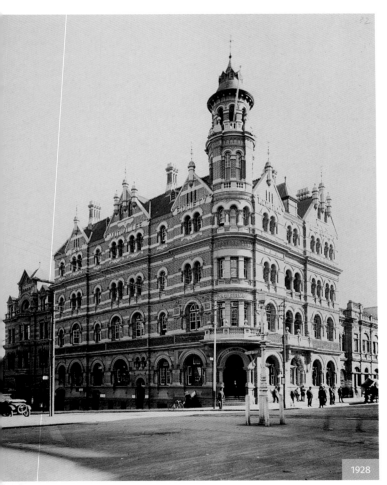

1928

T&G CHAMBERS / CITIBANK HOUSE

The elegant T&G Chambers survived until 1960

LEFT: Prior to the construction of T&G Chambers in 1897, the site was occupied by two buildings: the National Bank of Australasia and the United Service Tavern Hotel. In the early days of the Swan River Colony there was insufficient collateral to start a bank and it was not until 1837 that the Bank of Western Australia opened, followed in 1841 by the National Bank of Australasia, which opened a branch on the corner of St Georges Terrace and Barrack Street. This building survived until it was purchased by the Temperance & General Life Assurance Company, who commissioned architect J.J. Talbot Hobbs to design their new offices. At the back of the building was the headquarters of the Women's Christian Temperance Union, which was founded in 1892 to create a 'sober and pure world'.

RIGHT: The gracefully elegant T&G Chambers survived until 1960, when the need for more office space drove the owners to demolish the building and construct what was for some 10 years the tallest building in central Perth. Construction of the new, steel-framed building was not without problems, as the high water table in the area demanded raft-type foundations. When it opened in 1962 it was known as the T&G Building but changed its name to Citibank House after the bank became its sole occupier. By the 1980s, the building was in need of modernisation. Planning constraints meant it was not viable to demolish and rebuild once again, so an extensive refurbishment scheme was developed which involved completely changing the external appearance of the building. Of the buildings that once encircled the junction of Barrack Street and St Georges Terrace, only the State Buildings remain as a reminder of past architectural styles, the rest show evidence of a thriving, modern commercial city.

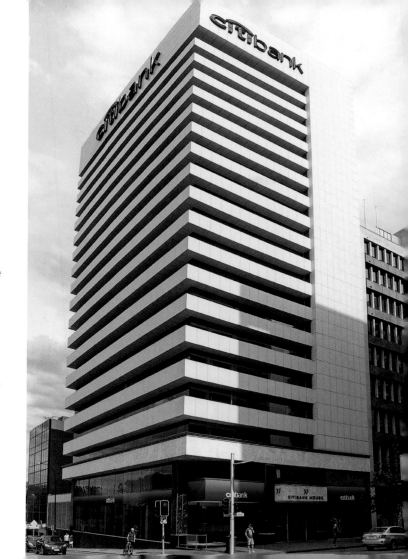

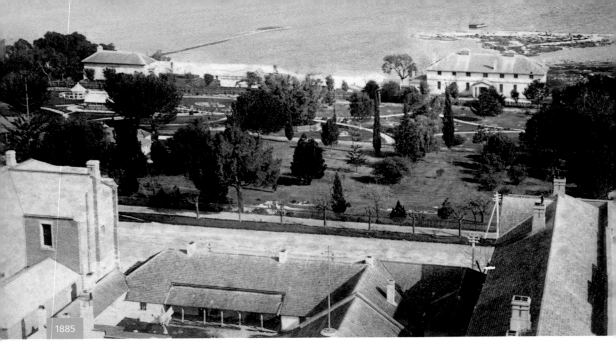

1885

GOVERNMENT GARDENS / STIRLING GARDENS

Perth's first public garden seen from the Town Hall's clock tower

ABOVE: Almost immediately after the foundation of Perth in August 1829, the Scottish-born naturalist James Drummond set up a 'naturalisation garden' within what would become Stirling Gardens. Here Drummond planted the seeds of various food crops brought with him from England in order to discover what would and would not grow successfully in this unknown climate. In addition to the vegetable and fruit varieties Drummond propagated, he also planted some acorns from which two oak trees, still to be seen in the garden, grew. The garden was gazetted as a botanical garden in 1845, becoming Perth's first public garden. A year later it was leased to Henry Cole, before returning to government control in 1856. The Governor's jetty can be clearly seen on the left side of the photograph. In the foreground are the early sections of Central Government Offices and beyond the gardens are the Court House (left) and the Commissariat Stores (right).

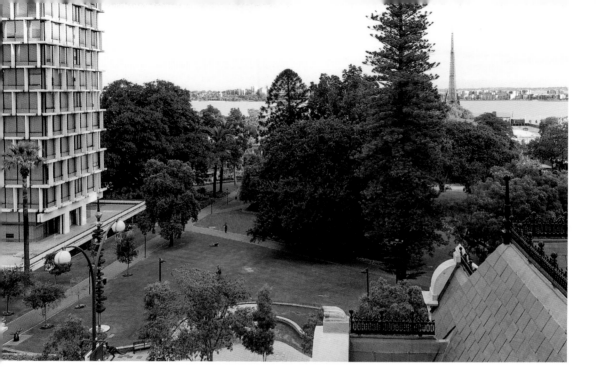

ABOVE: The park continued to be the city's botanic gardens until 1962 when the nearby Kings Park Botanic Gardens were officially established. Government Gardens (renamed Stirling Gardens in 1979) were redesigned in 1965 by the City of Perth Parks and Gardens Department, using Toodyay stone for retaining walls and shallow pools, one of which has a much-photographed group of bronze kangaroos at the water's edge. The garden also features other sculptures such as the statue of Alexander Forrest (1849–1901), a prominent Western Australian explorer, politician and Mayor of Perth. Other features include the Holocaust Memorial and (visible behind the lamp-post on the left) Harmony of Minerals, an ore obelisk erected in 1971. The obelisk consists of a 14-metre (46-foot) oil drill pipe on which have been threaded 15 different Western Australian ores representing the natural wealth of the state. On the left of the photograph is the corner of the 1963 Council House office block, while over the roof of the Central Government Offices, by the river, is the glass spire of the Bell Tower, which opened in 2000 as part of Western Australia's millennium celebrations. Drummond's original oak trees can still be found among the central block of trees in this photo.

THE WELD CLUB
An exclusive gentlemen's club since 1871

BELOW: The Weld Club was founded in 1871 as an exclusive gentlemen's club named after Frederick Weld, Governor of Western Australia from 1869 to 1875. The club's members, who were from the upper echelons of Perth society, met to discuss politics, play billiards, invest in an informal stock exchange and read the latest news in British newspapers. Initially meeting in two houses on St Georges Terrace, the club decided in 1890 to build a much larger clubhouse on a prestigious block of land on the corner of the Esplanade and Barrack Street, which had previously been occupied by the home of the Dean of St George's Cathedral. A design competition was held and the winner, J. J. Talbot Hobbs, created a two-storey building, which was officially opened in December 1892.

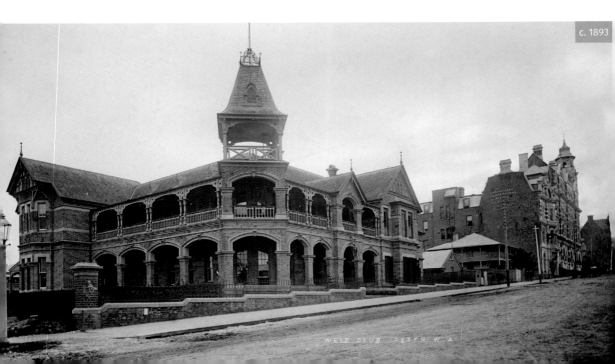

c. 1893

WELD CLUB PERTH W A

BELOW: By the beginning of the 20th century the club had grown sufficiently for a large extension, which was built especially for country members who required accommodation when visiting the city. An extension, which doubled the size of the club, was opened at the end of 1904. In 1985 a restoration plan for the building was funded by leasing some of the club's land to create Exchange Plaza, a high-rise office development housing the Australian Securities Exchange. Although it is now dwarfed by this 40-storey development, the Weld Club continues to operate out of its historic premises. Described in 1892 as a 'unique centre of sociability' allowing for 'pleasant contact with everybody who is anybody in the small capital of the largest colony', this exclusive, male-only private club continues to thrive.

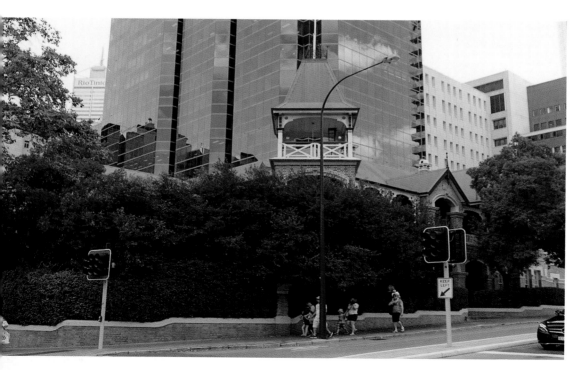

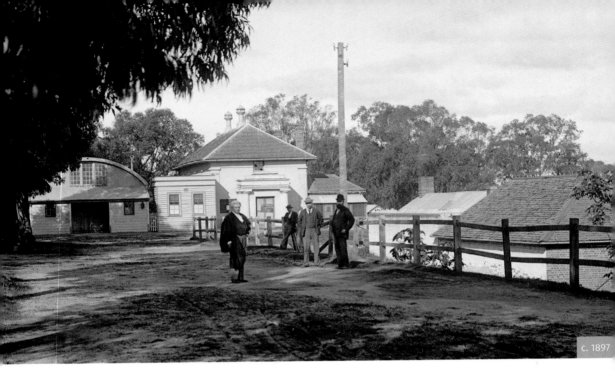

c. 1897

OLD COURT HOUSE
The oldest building in central Perth

ABOVE: Soon after the first Swan River Colony settlers arrived, James Stirling issued a proclamation declaring that British statute law and common law would apply to the new colony, with Stirling initially the sole arbitrator. At first, court was held in the Rush Church on the corner of Hay and Irwin Streets, but by 1836 it moved into a courthouse designed by Henry Reveley. The building was described as 'chaste and appropriate' and cost £698 to build. The first Court of General Quarter Sessions was held there on January 2, 1837. For the first few years of its life, the building not only served as a court room but also the colony's theatre, concert hall, school and church. The Perth Drill Hall (with the curved roof) was built next door in 1896 as a response to a perceived need for better military training in the state.

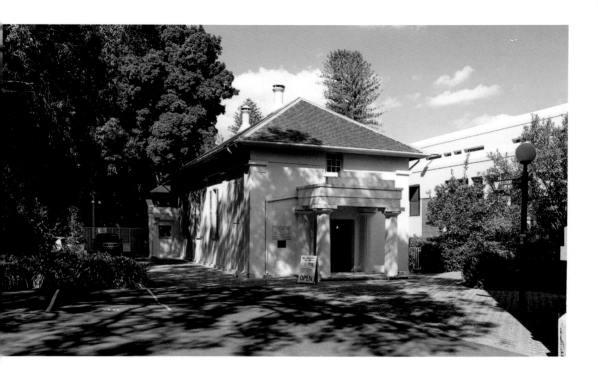

ABOVE: Now the oldest-standing building in Perth, the courthouse was initially the only public building capable of accommodating large gatherings. As a result, in its early days it also functioned as an immigration depot and community centre. As the colony grew, so did the workload of the court, which often sat for 18 hours a day. In 1841 it was reported in the *Perth Gazette* that a criminal trial ended at 3 a.m., only after the accused had roused the jury to listen to his defence. By 1879 the case load became impossible to accommodate and judicial matters transferred to the neighbouring Commissariat Stores. From 1905 until 1965 the building was used by the Arbitration Court. It became home to the Law Society of Western Australia from 1965 to 1987 and was later opened to the public as a museum. The Old Court House Law Museum is now open from Tuesday to Friday weekly. The drill hall next door was demolished to provide extra parking for the Old Court House.

PERTH CITY BATHS

Perth's first swimming pool

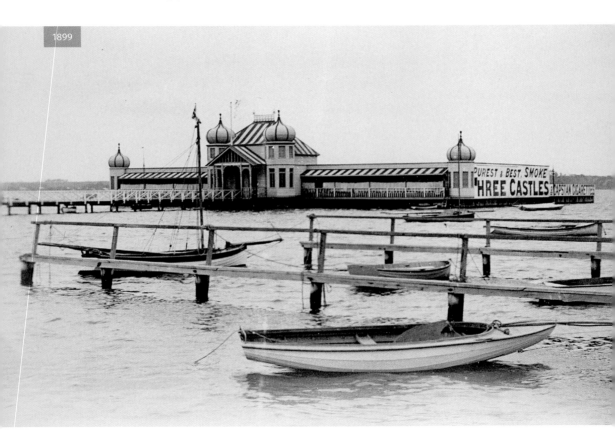

1899

LEFT: With a climate conducive to the sport, swimming in the Swan River was popular from the very beginning of British colonisation. In the 1870s the need for a proper public bathing facility was discussed and a tin shed and water enclosure was eventually erected between Barrack and William Street jetties. This led to what one newspaper described as 'unrefined behaviour' by swimmers, who paid 'un-costumed visits to the mainland'. A Perth Bathing House Fund was established and the City Baths were built at a cost of £2,600 in 1898. The ornate Moorish Revival structure was designed by G.R. Johnson. The view in this photo shows a fledgling South Perth in the background.

BELOW: The muddy river bed, combined with a frequent lack of deep water, meant that the City Baths were never popular. Following the opening of the Crawley Baths in 1914, the City Baths were partially demolished and completely removed in 1920. The creation of Riverside Drive in 1937 effectively divided the area where the entrance to the baths was from the Esplanade Reserve. With the advent of the Elizabeth Quay project, which was completed in 2016, the area where the baths used to stand became part of the new river inlet, once again uniting Perth citizens with that part of the river. The new footbridge over the inlet entrance makes a graceful centrepiece.

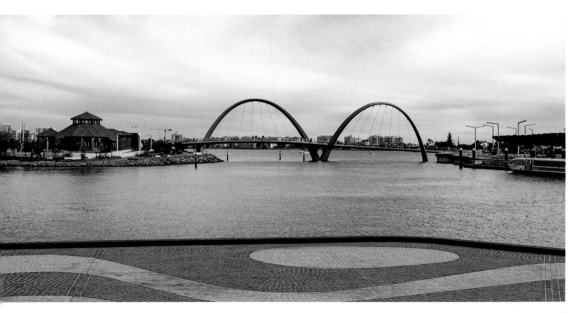

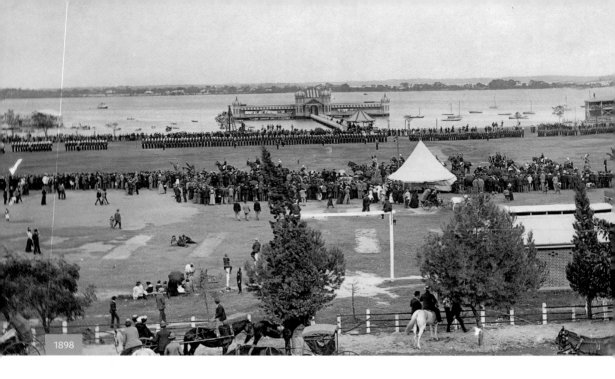

1898

ESPLANADE RESERVE / ELIZABETH QUAY

The Esplanade was open for sporting events, public gatherings and 'moral amusements'

ABOVE: The Esplanade Reserve was reclaimed from the river as part of a city council scheme to provide more spaces for 'moral amusements and manly sports'. Work to create new land between Barrack and William Street jetties began in 1873 and was completed in the early 1880s, when soil removed to level St Georges Terrace was added. Initially, an open drain running down Sherwood Court made the ground a very unpleasant place to be, but once this had been covered in, a Recreation Ground was opened in 1885. The event taking place in this photo from 1898 is a celebration of Queen Victoria's 79th birthday, attended by over 6,000 people. In the background is the ornate City Baths (centre), the clubhouse of Perth Yacht Club (far right) and a very sparsely populated South Perth in the distance.

20

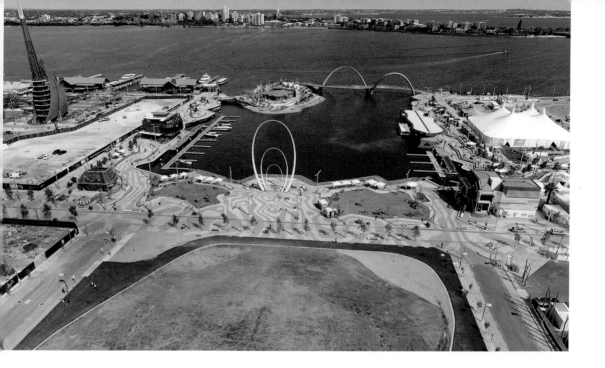

ABOVE: By the beginning of the 20th century, the Recreation Ground was home to the Metropolitan Cricket Club, Perth Bowling Club, tennis courts and Perth Yacht Club. The ground also became the venue for many civic and national ceremonies, such as the celebration of Australian Federation on 1 January 1901. With some alterations in the 1920s, the Esplanade remained as popular as ever for sporting and cultural events. During the last decade of the 20th century a number of plans were suggested for the redevelopment of the Esplanade in order to 'reconnect' the city-centre with its river. In 2011 the State Government announced a scheme for the creation of Elizabeth Quay, to provide a waterside amenity including an inlet from the river, a pedestrian and cyclists' bridge and other leisure facilities. Elizabeth Quay was officially opened on 29 January 2016, with Spanda, a rippling water-inspired sculpture as its centrepiece. Eventually, the empty areas will be occupied by high-rise buildings that will dwarf the Bell Tower (Swan Bells) on the left of the photograph. South Perth, on the opposite side of the river, has grown considerably since the earlier photograph was taken. The photograph was taken from the top of the Atlas Building on the Esplanade.

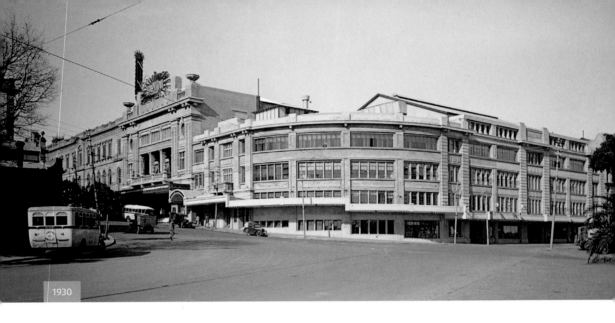

1930

CAPITOL THEATRE AND TEMPLE COURT CABARET

Two popular entertainment venues at the southern end of William Street

ABOVE: Designed by George Temple-Poole and Christian Mouritzen, the Art Nouveau Capitol Theatre (left) was opened in May 1929 and was the first in Australia with RCA Photophone – used for early 'talkies'. Other features of the cinema included a huge illuminated sign on the roof and a bust of Rudolph Valentino in the dress circle foyer, said to have permanently red lips from the kisses of fans. Another novel convenience offered by the theatre was a free bus service. The theatre's neighbour, the Temple Court Cabaret, was opened the same year on the corner of William Street and the Esplanade. It was a mixed-use building that included a theatre as well as a car park, tea room and offices.

RIGHT: Although it had a reputation for poor acoustics, in the 1930s the Capitol Theatre became the main concert venue in Perth and home of the West Australian Symphony Orchestra, until they moved to the ABC's Basil Kirke Studios in the early 1960s. In 1966 the theatre was bought by entrepreneur Thomas Wardle, who sold it two years later, when it was demolished. After financial difficulties, the Temple Court Cabaret, then sharing its building with Sydney Atkinson Motors, was relaunched in 1933 as the Embassy Ballroom, which, with its magnificent décor, became a very well-frequented dance venue right up until its demolition in 1984 to make way for Wesfarmers House office block.

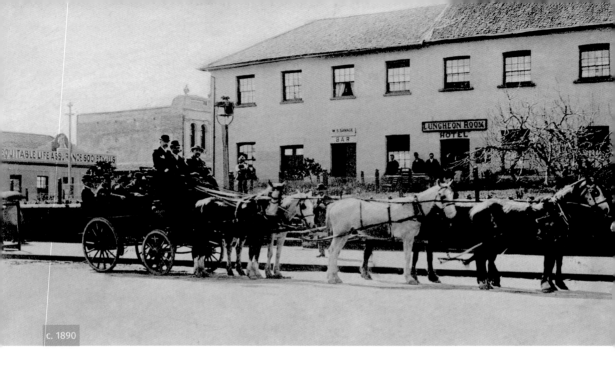

c. 1890

FREEMASON'S HOTEL / PALACE HOTEL
The first licenced hostelry in central Perth

ABOVE: The King's Head Hotel, the first licenced hostelry in central Perth, was opened on the corner of William Street and St Georges Terrace by William Dixon in 1830. A year later Dixon reassigned the property to William Leeder and it became known as Leeders Hotel, which was popular with gentlemen settlers and military officers. The scene of many grand dinners and celebrations, the building was extended in 1845, by which time it was referred to as the Freemason's Tavern, as it accommodated the first Masonic lodge in Western Australia. Still in the ownership of William Leeder's widow, fire destroyed several outbuildings at the rear of the property in 1888, by which time it was said to be in a dilapidated state. When this early 1890s photo was taken the reopened hotel, bar and luncheon room was being managed by a W. S. Savage.

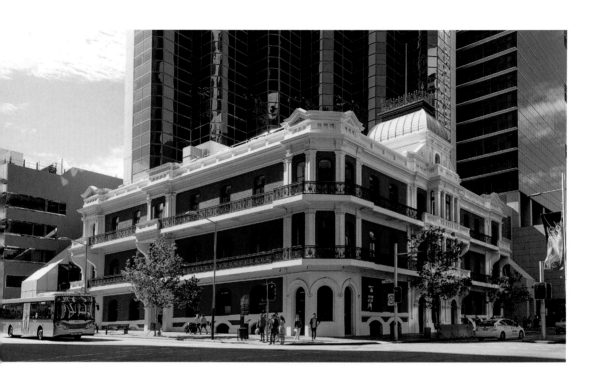

ABOVE: The hotel was sold in 1894 to John De Baun, an American property investor and hotelier, who engaged architects to design a new hotel of the highest quality. No expense was spared in gathering the best materials from around the world to create the luxury establishment. The Palace Hotel, as it was renamed, proudly boasted 'electric light and gas laid on in every room'. The Commonwealth Banking Corporation purchased the property in 1972 and announced it was to be demolished. This caused a public campaign for the building's preservation, which was led by a group known as the Palace Guards. In 1978 the Bond Corporation purchased the property and adjacent ones, building the 50-storey office block which sits on the northeast corner of the building. Much of the original hotel survived this addition and was used as a bank. In 2015–2016 the old building underwent an extensive renovations program and was converted into offices and a restaurant.

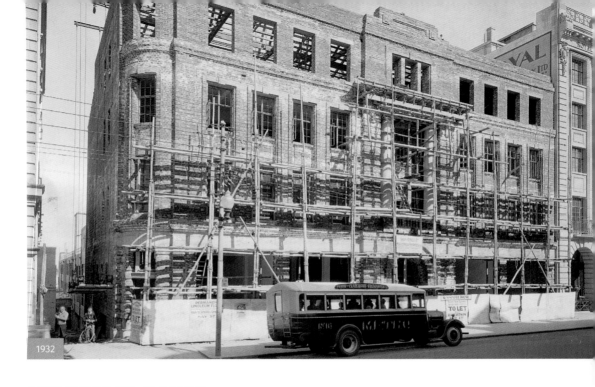

1932

NEWSPAPER HOUSE

'Meet you at the clock' meant only one building for Perth's older residents

ABOVE: The *Perth Gazette* and *Western Australian Journal* was first published on 5 January 1833. Coming into the hands of a number of owners and changing its name several times, it eventually became the *West Australian* in November 1879. Having become a daily newspaper in 1885, it established itself as a force to be reckoned with throughout the state and moved to a four-storey building on St Georges Terrace, east of William Street, known as West Australian Chambers. From here they moved to the newly constructed Newspaper House, also on St Georges Terrace, designed by architects Hobbs, Smith & Forbes. The building cost of £95,579 and opened during the centenary of the newspaper in 1933.

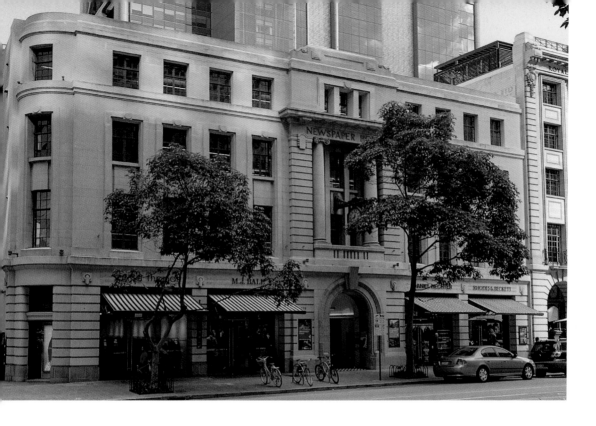

ABOVE: In November 1935 Newspaper House was awarded the Royal Institute of British Architects medal for the best street facade. For older Perth residents, the phrase, 'meet you at the clock' instantly conjures up a mental picture of the double-sided clock on the front of Newspaper House, which has been a popular meeting place for many years. The West Australian vacated the premises in 1988 and moved to Osborne Park. Newspaper House remained vacant for 20 years, until the plot behind was bought by BHP Billiton who constructed a 46-storey skyscraper between 2008 and 2012. Approval for the new office complex included strict conditions on maintaining the heritage value of the buildings along St Georges Terrace, which now form part of Brookfield Place, and are used as shops, offices and restaurants.

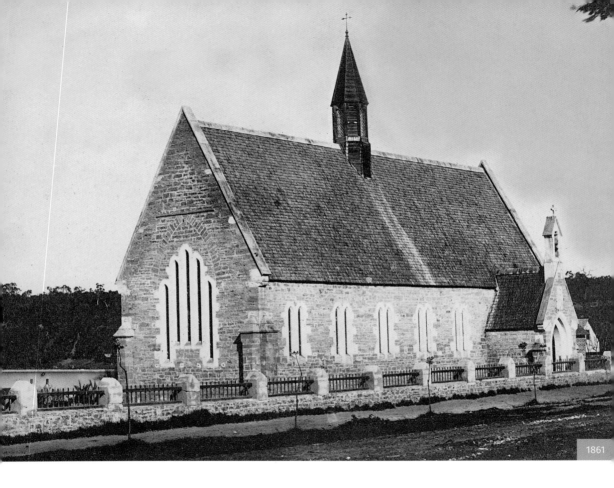

1861

PERTH BOYS' SCHOOL
The first custom-built school in Perth

28

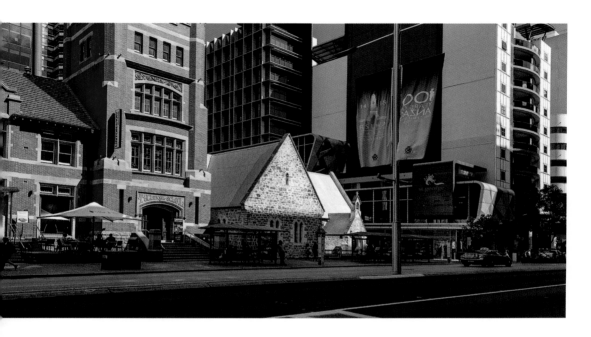

LEFT: In the first few years of the Swan River Colony, thoughts of educating the youngsters took second place to survival in a hostile environment. News of the lack of a school got back to England. As a result, a colonial school was set up under the tutelage of John Cleland, a carpenter by trade, and for 17 years lessons of varying quality took place in temporary buildings around the town. An education committee was eventually convened and led to a school being built in St Georges Terrace, on the site of a mill. Designed by the Colonial Secretary, William Sandford, construction of the school started in 1853 using convict labour, but a shortage of materials delayed completion until 1854.

ABOVE: The new school was built in the style of a church in order to imbue the pupils with a sense of duty, attentiveness and obedience. The building continued in use until the 1890s, when it was deemed too small. A new school was built in James Street and the old one became the library for the new Perth Technical School. The impressive red-brick building on the left was built especially for the Technical School in 1910. In the mid-1980s the college moved to other sites and the old Perth Boys' School was vested with the National Trust and leased as a café. In 2016 the use of this building turned full-circle and, conserved and restored, it has become a city-centre venue for Curtin University.

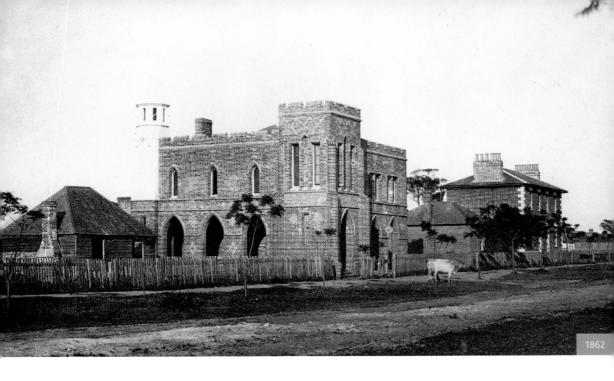

1862

BISHOP HALE'S SCHOOL / THE CLOISTERS

The first secondary school in Western Australia

ABOVE: The inaugural Anglican Bishop of Perth, Matthew Blagden Hale, had a keen interest in education and founded the first secondary school in Western Australia. After a fundraising campaign, which included a substantial personal donation from the bishop himself, a school building was designed by Richard Roach Jewell and built by convict labour on St Georges Terrace at Mill Street.

Officially known as the Perth Church of England Collegiate School, it mainly attracted wealthy young men as pupils. The opening of the new school was reported in the *Inquirer* newspaper on 30 June 1858: 'The Bishop's School, Perth, was opened on Monday, when there was an attendance of about 23 scholars, a very good commencement.'

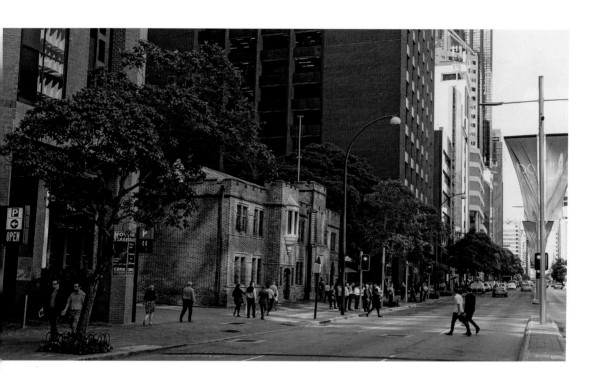

ABOVE: The building, which became known as the Cloisters, was enlarged and remodelled in 1879–80 and continued as a school until 1914. After this it was used by the Anglican Church as St John's University Hostel to provide accommodation for students at the newly formed University of Western Australia. In 1931 the building was damaged by fire and demolition was considered to make way for new buildings and a continuation of Mill Street. Instead, £2,000 was spent on its restoration, after which it had various uses, including as a WAAF barracks. Demolition was once again on the cards in the mid-1960s, but a campaign in the *West Australian* generated public support for its retention and it was incorporated into a scheme for office buildings with a plaza and shopping arcade, which forms the building's backdrop today. Although the Cloisters stopped being used as a school over 100 years ago, Hale School is still up and running, now in Wembley Downs, making it the oldest private boys' school in Western Australia.

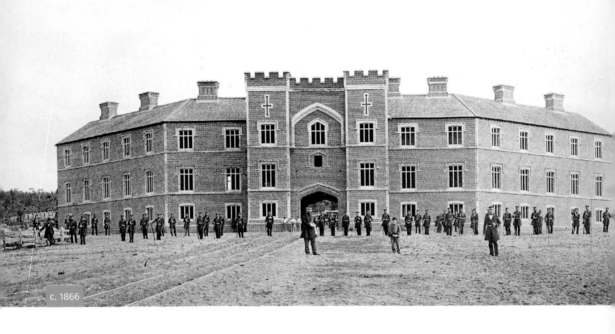

c. 1866

PENSIONER BARRACKS

The Tudor-style gatehouse arch is all that remains

ABOVE: The introduction of convicts in 1850 to augment the local labour force meant that people were also required to supervise and guard the prisoners. The Enrolled Pensioner Force, which was made up of retired British military personnel, travelled as guards on the convict ships arriving in Western Australia. On arrival, members of the force were offered a choice of 10 acres of land with which to make a living, or the opportunity to continue work as guards. For those who continued as guards, accommodation was required and so the Pensioner Barracks was designed by architect Richard Roach Jewell and constructed mainly by convict labour. The first families moved into their two-roomed apartments in 1866. Additional facilities for the barracks complex included a cook house, firing range and gun room, wash house, stores and stables and, later, a fives court. This photo shows the Enrolled Guards, as they later became known, standing in front of the nearly completed barracks.

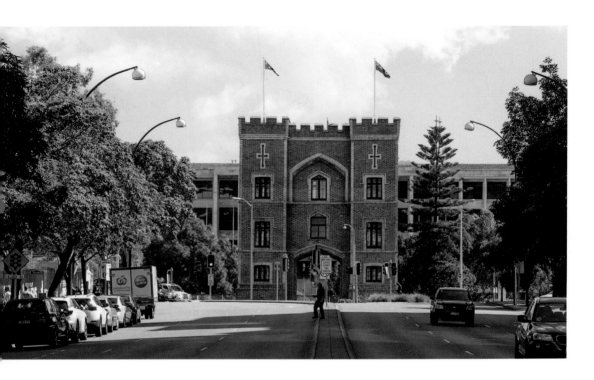

ABOVE: The introduction of the Enrolled Pensioner Force only lasted for 18 years, but during that time some 2,500 guards and their families came to live in Western Australia. The force was disbanded in 1887 and the barracks were slowly converted into government offices. In 1960 the government announced that the barracks were to be demolished to make way for the Kwinana Freeway. This produced a public outcry and the Royal West Australian Historical Society formed the Barracks Defence Council to save the building. Despite this, demolition commenced and two bays of windows were reduced to rubble. Attention then turned to saving the gatehouse arch. After several polls to gauge public opinion, all of which were conclusively in favour of retention, a free vote was taken in parliament and a motion to demolish the arch was defeated by eight votes, leaving us with Perth's 'Arc de Triomphe' in front of Parliament House.

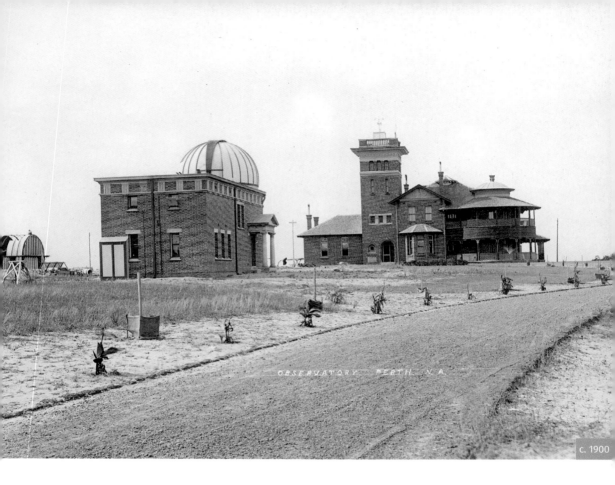

c. 1900

PERTH OBSERVATORY

Where standard time for Western Australia was first set

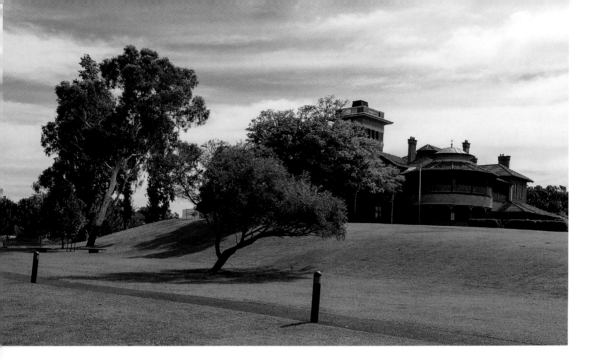

LEFT: Appointed in 1896, Western Australia Government Astronomer, William Cooke's first task was to determine the exact latitude and longitude of Perth, while overseeing the construction of an observatory on Mount Eliza. Designed by architect George Temple-Poole, Perth Observatory was officially opened in 1900 by John Forrest, the first Premier of Western Australia. As well as accurate time keeping, the observatory was responsible for weather forecasting, navigation, astronomy and seismology. To facilitate this, three buildings were constructed: the Transit Circle Building, with a meridian telescope; the dome, which was a steel structure, and the government Astronomer's residence and office.

ABOVE: Having accurately calculated the coordinates of Perth, the Government Astronomer was able to establish a standard time for Western Australia. From 1899 the correct time was displayed on a clock at the observatory gates. From November 1900 a signal was also sent electrically to a time-ball on Arthur Head, in Fremantle Harbour. The large ball dropped daily at 1 p.m. to enable ships' clocks to be set accurately. Due to excessive light pollution, the observatory was dismantled in the early 1960s and moved to a new site in the Darling Ranges. The one remaining building on the Observatory site is the former Astronomer's residence, now the headquarters of the National Trust of Western Australia.

PERTH PARK / KINGS PARK

The largest inner-city park in the world

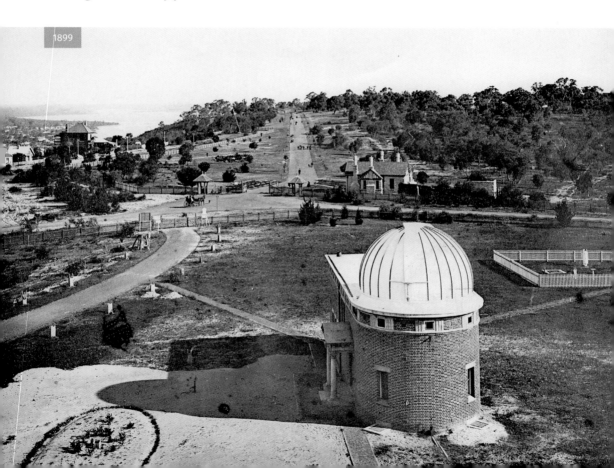

1899

LEFT: This photo was taken from the tower of the Government Astronomer's house shortly after Kings Park had been landscaped. In 1832 Surveyor General to the Swan River Colony, John Septimus Roe, refused to allow timber to be felled on Mount Eliza (named after the wife of Governor Darling of New South Wales) as he intended it to be a public park. His edict was ignored, as the first export from the colony was 5 tonnes of jarrah, cut down within the park. Thankfully, in 1871 Roe's successor, Malcolm Fraser, persuaded Governor Weld to gazette 1.75 square kilometres (0.68 square miles) as public reserve, thus creating Perth's famous park. In 1890 the first Premier of Western Australia, Sir John Forrest, enlarged the park to its present size.

BELOW: In honour of the accession of King Edward VII in 1901, the park was renamed King's Park (the apostrophe was later dropped). The trees planted in the last decade of the 19th century and the early years of the 20th, now completely obscure the entrance, but the paths, pavilions and tea rooms for rest and recuperation and facilities to play games such as croquet, bowls and tennis are still present. At 4.06 square kilometres (1.57 square miles), it is the largest inner city park in the world, beating Central Park in New York by 0.64 square kilometres (0.25 square miles). More importantly, it is a place enjoyed by about 6 million visitors every year, who use the area, as it has been for thousands of years, as a source of beauty and relaxation.

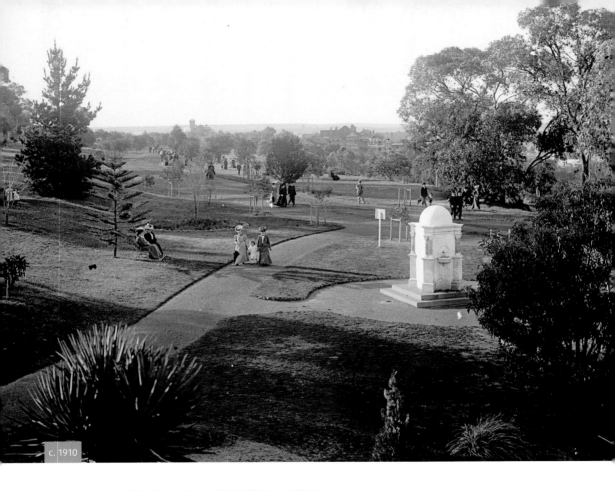

c. 1910

LEAKE MEMORIAL, KINGS PARK
A monument for the third Premier of Western Australia

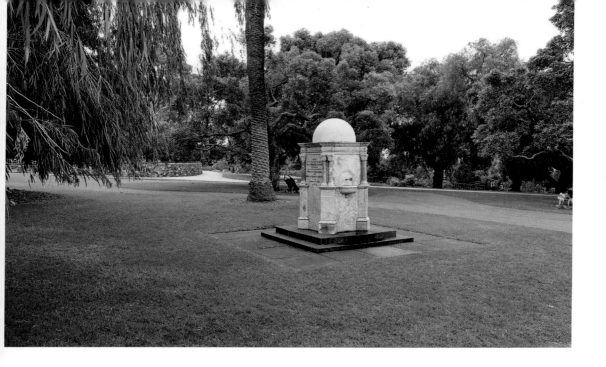

LEFT: George Leake had two very short terms as Premier of Western Australia in 1901 and 1902, the second coming to an end when he died in office. The memorial was the result of a bequest from Leake's wife, who specifically requested a marble drinking fountain. Designed in Byzantine style by James Linton, the art instructor at the newly formed Perth Technical School, the fountain was unveiled in July 1904. The meandering paths and shade-giving trees around the fountain show how Kings Park had been landscaped as a pleasure ground. In the background can be seen the Perth Observatory buildings built on the slopes of Mount Eliza.

ABOVE: Today the area surrounding the Leake Memorial is one of the most heavily used parts of Kings Park. Just to the south of the memorial are the West Australian Botanic Gardens. This feature was moved here from Stirling Gardens in 1962 in order to better show off the flora of Western Australia to those visiting Perth for the Commonwealth Games. Designed by John Oldham, the garden now houses examples of over half the state's 25,000 plant species, many of them unique to Western Australia. A recent addition to the collection is Gija Jumulu, a 36-tonne boab tree estimated to be around 750 years old, which was moved 3,200 kilometres (1,988 miles) from the Kimberley and planted in 2008.

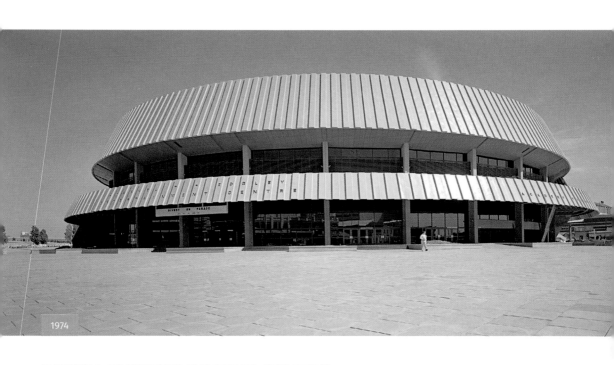

1974

PERTH ENTERTAINMENT CENTRE
Replaced by Perth Arena as part of the Perth City Links urban renewal project

ABOVE: Anyone in Perth who went to see David Bowie, AC/DC or Abba during the 1970s or 80s will remember the Perth Entertainment Centre. The brainchild of Brian Treasure of television station TVW-7 and theatrical entrepreneur Michael Edgley, this building was developed primarily to mount large stage and television shows in a custom-built venue. The construction was dogged with delays and interruptions, including strike action timed to coincide with key operations in the building process, which caused a budget overrun of $3 million. The complex, also containing a cinema, eventually opened as the Channel 7 Edgley Entertainment Centre in December 1974 with the Australian debut of the second Disney on Parade show.

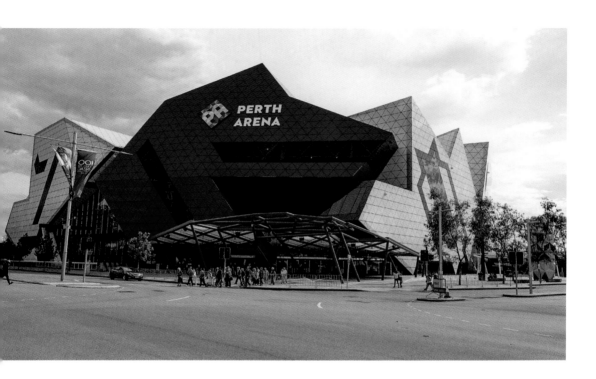

ABOVE: With 8,000 seats, Perth Entertainment Centre was the city's largest entertainment venue and was listed in the Guinness Book of World Records as the largest purpose-built theatre containing a proscenium arch in the world. From its opening until 2002, it played host to a large range of events including musicals, circuses and even a Miss Universe contest. From 1990 until its closure, the centre was also home to the Perth Wildcats basketball team. When it closed there were initially plans for the venue to be redeveloped, but they never materialised. Eventually, Western Australia Government unveiled plans for a new arena to be built next to the old centre. The disused building was demolished in December 2011, to make way for the Perth City Link, reconnecting the city centre to Northbridge by means of sinking the Fremantle railway line. Its replacement, the Perth Arena, was opened in November 2012. The new entertainment and sporting arena has a full capacity of 15,000.

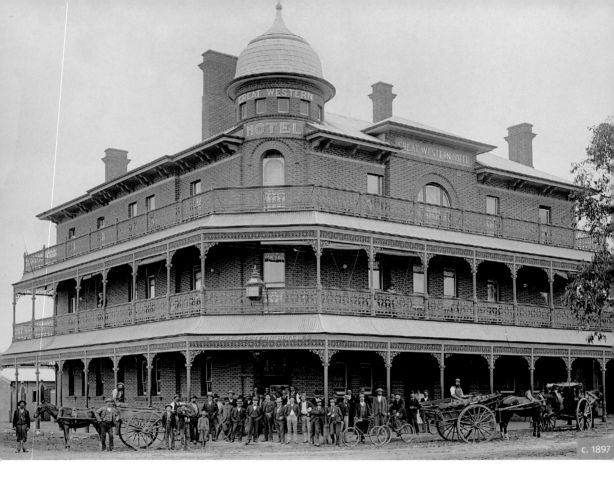

c. 1897

GREAT WESTERN HOTEL

The remarkably well-preserved hostelry still graces the corner of William and James Streets

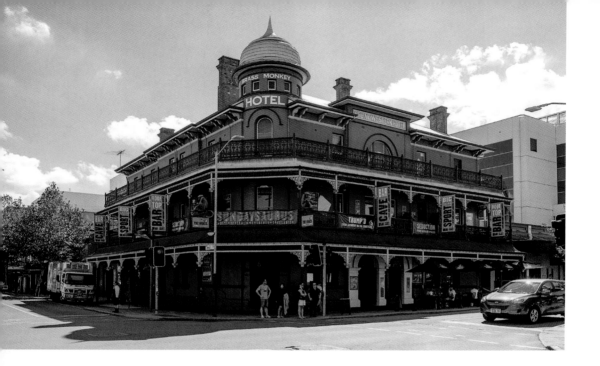

LEFT: After the Fremantle to Guildford railway line was completed and gold was discovered at Coolgardie, a large number of new buildings sprang up in the area centred on Perth Railway Station. Part of this rush of development was the Great Western Hotel. The hotel opened in November 1896 and received a glowing review in the *West Australian*, which was very complimentary about the lavish Federation Filigree design by local architect Michael Cavanagh. The cart on the right-hand side of the photograph belonged to Boan Bros., an emporium which Harry and Benjamin Boan had opened just over the railway line a year before the hotel. Boans became one of the best known department stores.

ABOVE: By the beginning of the 20th century, the Great Western Hotel had become one of the most popular hotels in Perth, probably because of its close proximity to the railway. An advertisement in the 1900 Christmas edition of the *Western Mail* drew attention to the convenient location and other attributes of the accommodation: 'It is most advantageously situated, being only one minute's walk from the Railway Station, and commanding one of the best views of the Metropolis.' Following a $1.5-million restoration in 1989, the hotel was renamed the Brass Monkey, after a beer brewed by the owners, and remains one of the most popular bars in Perth.

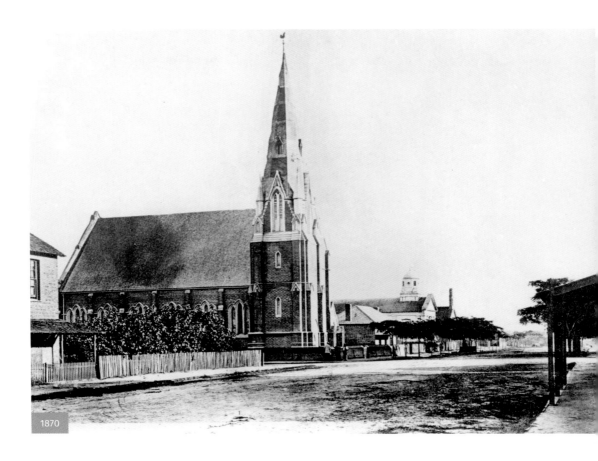
1870

WESLEY CHURCH

A continuous place of worship since 1870

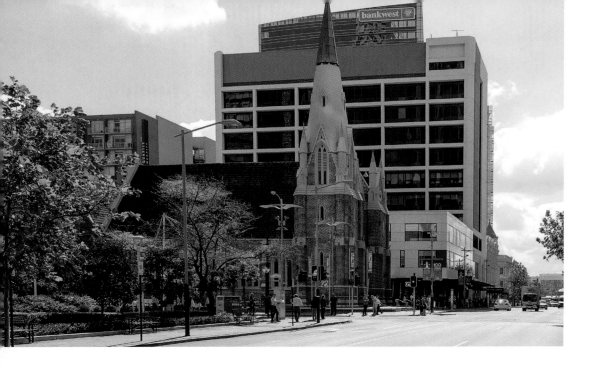

LEFT: A block of land on the corner of Hay and William Streets was purchased in 1867 by the Methodist congregation of Perth in order to build a new church for their growing flock. To encourage public donations for the new church, a pew incentive scheme was developed, by which the best seats in the church were allocated to those who donated the most money. George Shenton (later the first Mayor of Perth) and Joseph Hardey (a farmer and Wesleyan layman) would have been in the front row, as between them they donated half the required funds. The church was designed by Richard Roach Jewell and completed shortly before this photograph was taken in 1870.

ABOVE: In 1875 Wesley Church became the proud owner of the first pipe organ in Western Australia. Some 20 years later, galleries were constructed on each side of the nave. More recently the church has undergone two major restoration projects, one to repair the damage from the Meckering Earthquake of 1968, with a further $150,000 being spent 20 years later. The church also redeveloped some of its land around the north and west sides of the church with the construction of the Wesley Arcade and Tower (behind), which opened in May 1976. In relatively recent times, the corner outside the church has become a well-known Sunday afternoon speakers' corner.

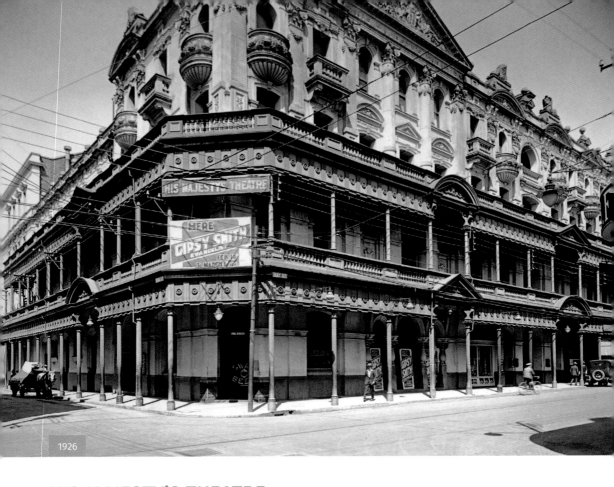

1926

HIS MAJESTY'S THEATRE
The most majestic theatre building in Western Australia

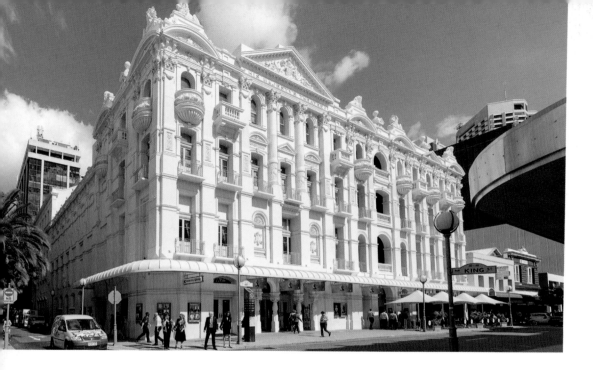

LEFT: The plot on which His Majesty's Theatre sits had been a popular entertainment venue for fairs and outdoor theatre since the 1870s. In 1902 Thomas Malloy, one of the wealthiest men in Perth, acquired the plot in order to give Perth its second theatre. His Majesty's Theatre was designed by architect William Wolf who immigrated to Australia in 1877. He worked in Sydney and Melbourne before setting up practice in Perth in the mid-1890s. Costing £46,000 and taking around two years to complete, the building was constructed by Gustav Liebe, who also built the Melbourne Hotel. The opening of the theatre in 1904 was postponed several times before taking place on Christmas Eve.

ABOVE: The auditorium featured four artificial waterfalls, reputed to improve ventilation, which disappeared early in the life of the theatre, probably because they gave those in the front rows of the stalls an unexpected shower. The theatre is believed to be the only remaining working Edwardian theatre in Australia. Sadly, the original facade was altered significantly after World War II, when the original balconies were demolished in order to conform to local byelaws. The building was nearly demolished in 1971, but local supporters mounted a successful campaign for its retention and it was extensively renovated in the late 1970s. Today it remains a popular performing arts venue.

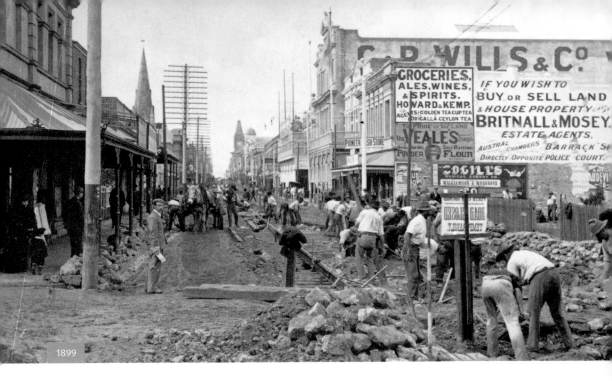

1899

HAY STREET TRAMLINE CONSTRUCTION

Trams served the city and its suburbs from 1899 to 1958

ABOVE: The first gold rush brought a huge population explosion to Perth which necessitated the creation of new suburbs. As a result, the need for a cheap, reliable public transport system became an imperative. During the last half of the 1890s a number of newspaper correspondents suggested that a tram system would fill the need. After much debate about the initial route, Hay Street was decided upon and the work of laying the tram lines commenced at the end of January 1899. By early July of that year, the *Kalgoorlie Miner* was able to announce that the first test run of a tram had taken place and the line would be open in a couple of months. The spires of Wesley Church and the Town Hall can be seen in the distance.

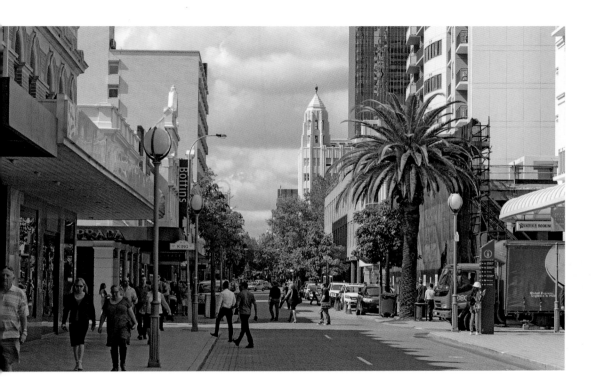

ABOVE: The opening of the first tram service in Perth, operated by Perth Electric Tramways, took place on September 28, 1899. A report the following day in the *West Australian* suggests it caused quite a stir: 'The principal event in the city yesterday was undoubtedly the opening of the Hay Street tram cars to traffic.' As the city grew, so did the tram system, which weaved its way through a number of suburbs. After World War II the system was considered old-fashioned,

so was replaced by trolley-buses, with the last tram running in 1958. Today, while there has been much debate about the reinstatement of a tram service, the city centre's fare-free public transport system includes CAT buses, which operate on four routes around the central business district. The spires of Wesley Church and the Town Hall are now obscured by other buildings, but the elegant Art Deco lines of the Gledden Building tower are visible on the right.

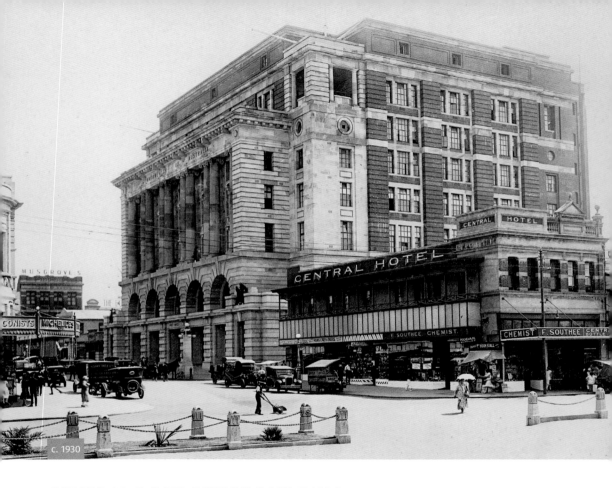

c. 1930

GENERAL POST OFFICE BUILDING
Architectural elegance and grandeur in Forrest Place

50

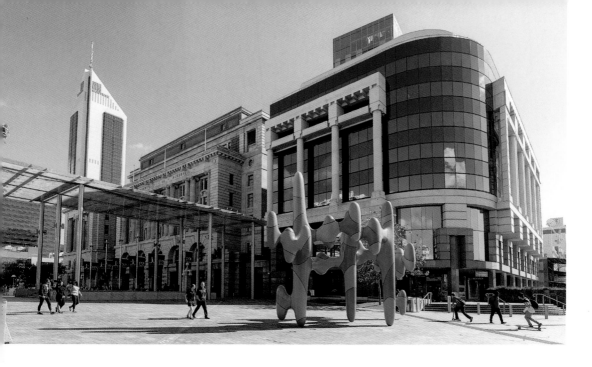

LEFT: Land opposite the railway station, including Central Arcade, was acquired by the Commonwealth Government in 1911 to create a precinct to which government departments could move from the cramped Treasury Building. The proposal was for a new street (Forrest Place) through the site, on which a General Post Office would be built. Eventually, groundwork for the Beaux-Arts-style GPO building commenced in July 1914. War intervened, however, and construction ground to a halt. After the war, the project was further delayed by several changes to the design, eventually opening in September 1923. The Central Hotel, on the corner of Wellington Street, first appears in the street directory in 1909.

ABOVE: In 1933 the precinct was enlarged by the addition of the Commonwealth Bank, south of the GPO. Designed in a similar style to its neighbour, it makes an elegant compatriot in an area dominated by modern buildings. Forrest Place was closed to traffic in 1987 to create a pedestrian mall with the GPO building as its backdrop. In recent years the mall has been refurbished with the addition of a children's water play feature, stage area and a distinctive sculpture, 'the Cactus', at the northern end. Forrest Place, which has long been a favoured venue for protests and rallies, continues to be a community focal point of the city.

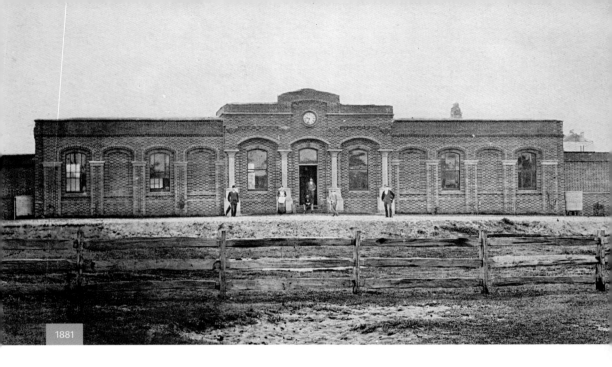

1881

PERTH RAILWAY STATION

A modest station serving Perth's first passenger railway service

ABOVE: After much debate about the need and route, the Fremantle to Guildford railway was constructed and the first train ran on a 3-kilometre (1.9-mile) section of track from Fremantle to North Fremantle in August 1880. In March the following year the line was opened to Guildford, later being extended to Midland Junction and on to Northam. One of the principal stations on the line was that in central Perth and designs for the building in neoclassical style

were drawn up by architect George Temple-Poole. The building had one through-platform (the line was initially run on a single track) and two terminating bay platforms, one at each end of the station. Within a very short space of time both passenger and goods traffic on the line exceeded all expectations. Just visible behind the station is the top of the 1856 Perth Gaol.

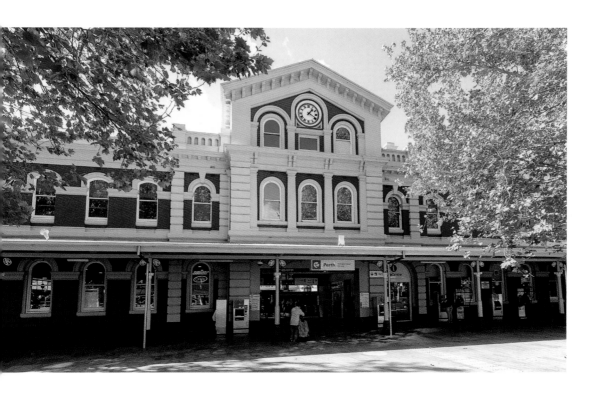

ABOVE: With the formation of the Western Australian Government Railways to run the new rail system, administrative offices were required and a second storey was added to Perth Railway Station, which remained the department's headquarters until it was disbanded in 2003. A planned third storey with an imposing clock tower was never built, but a number of station buildings have been added to the complex over the years. The Fremantle to Midland line was closed in September 1979, but, following public outcry and a vigorous campaign, the line reopened in 1983. As part of the enlargement of the metropolitan rail network, the station was refurbished and two new underground platforms, built at 90 degrees to the existing ones, were opened in 2007. Today Perth Railway Station is an important transport hub serving many hundreds of thousands of commuters every year.

PERTH BOYS' AND GIRLS' SCHOOL / PICA

The heritage building is now at the heart of Perth Cultural Centre

BELOW: Enrolments in the boys' school on St Georges Terrace grew so much in the 1880s and 90s that the building was unable to accommodate them all. To address this, construction of a new school building started in 1895. Two years later, Perth Boys' and Girls' School in James Street, north of the railway line, was officially opened by the Minister for Education, Edward Wittenoom. The new building, which accommodated 500 boys on the ground floor and 500 girls on the upper, was the largest project undertaken by the Education Department in that era. At the time of opening, the girls and boys each had separate entrances to the school. In 1900 two additional classrooms were added, each designed to house a further 75 children.

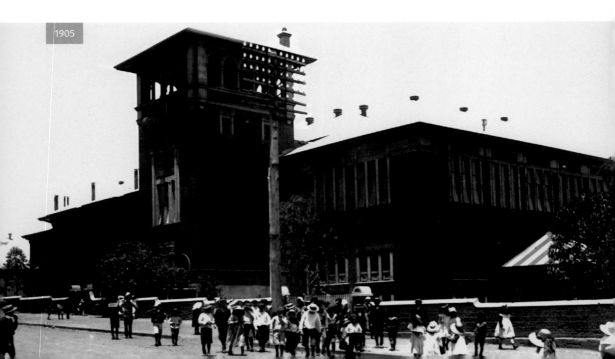

1905

BELOW: In 1936 a new girls' school opened in East Perth and the entire James Street complex was given over to the boys' school, which, 11 years later, was renamed Perth Boys' High School. During the 1950s, residential development in the inner city decreased and the growth of the suburbs displaced inner city living. The school closed in 1958 and the building was used by Perth Technical College until 1988. Now the home of Perth Institute of Contemporary Arts (PICA), the old school has a number of defined spaces including a café, performance space, gallery and administrative offices. PICA is situated right in the middle of the Perth Cultural Centre, which is home to a number of cultural institutions such as the Art Gallery of Western Australia, Western Australian Museum, State Library of Western Australia and the State Theatre Centre.

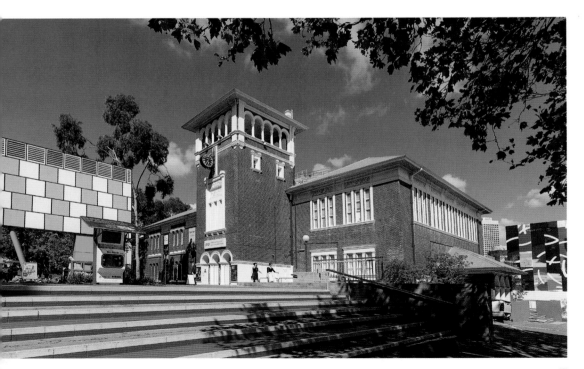

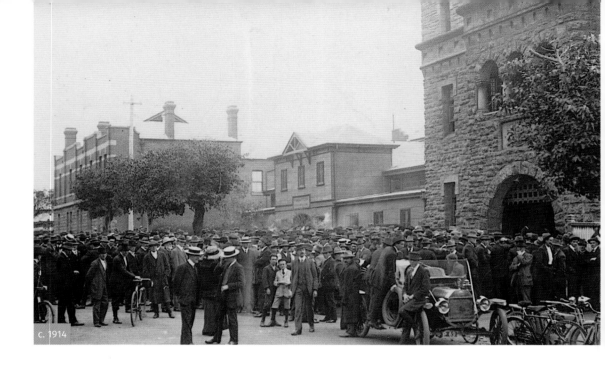

c. 1914

SWAN BARRACKS

The fortress-like entrance now welcomes backpackers

ABOVE: An 1896 report by the Commandant for the Local Forces of Western Australia expressed concern that local Volunteer Corps in the state were not sufficiently well organised, trained or disciplined for war. The report concluded that competent instruction in good drill halls would significantly improve this. As a result, Swan Barracks was built the same year as one of these drill halls. The location was considered central enough for use by the Perth Company of WA Rifle Volunteers, who shared the space with school cadets. A fortress-like stone building with portcullis, designed by George Temple-Poole, was added in 1897. This striking Francis Street entrance to the barracks was built to provide space for administrative offices. This photograph shows men enlisting at the Swan Barracks during World War I.

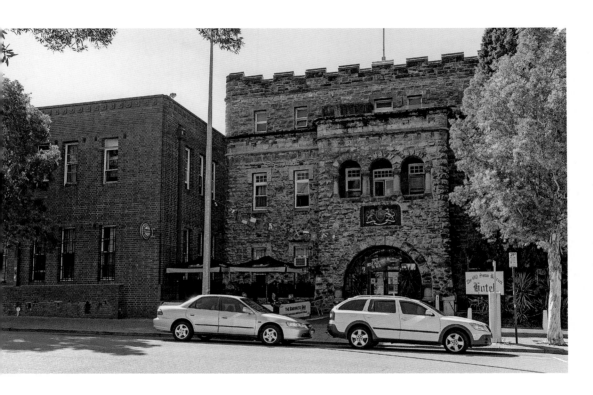

ABOVE: At the beginning of the 20th century, the Swan Barracks gained a number of additional buildings and a third storey to the administrative offices. Following Federation on 1 January 1901, the barracks were incorporated into the Australian Army and became the Fifth Military District Headquarters, which played a significant role during World War I as a recruitment and training centre. During the first years of World War II, further enlargement took place and a new wing was added on the west side in the mid-1950s. Throughout these alterations, George Temple-Poole's citadel-like building remained a focal point, as it does today. The army vacated the barracks in 1992 and moved to the old HMAS Leeuwin site in Fremantle. Eventually the barracks site was sold in 1999 and is now a popular city-centre backpackers' hostel.

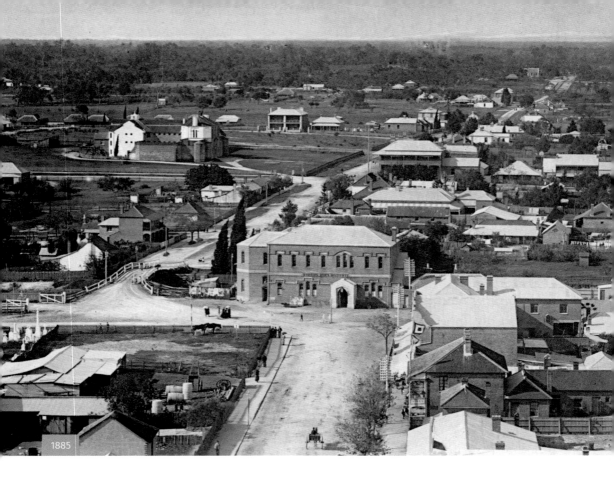

1885

BARRACK STREET BRIDGE
The rebuilt bridge helped to improve the alignment of Barrack and Beaufort Streets

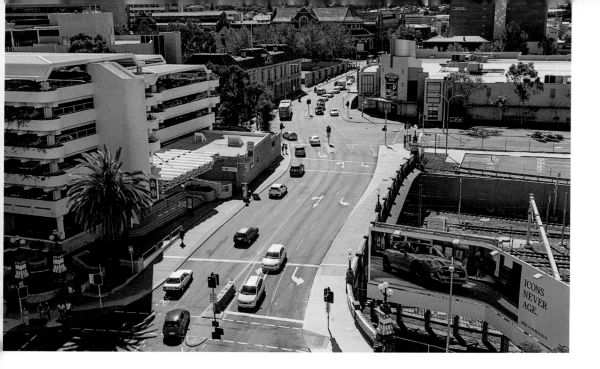

LEFT: To carry Beaufort Street across the new Guildford to Fremantle railway line, a timber bridge (centre left) was constructed in 1880. The bridge proved to be too narrow and in constant need of repair. Eventually a new, more substantial bridge was built in 1894. The construction of this bridge offered an ideal opportunity to improve the alignment of Barrack and Beaufort Streets, which had a very awkward dog-leg, much hated by cab drivers. By pulling down the Working Men's Institute (centre), on the junction between Barrack and Wellington Streets, a much safer junction was created. The large building on the upper-left-hand side is the Old Perth Gaol of 1856.

ABOVE: With a heavy increase in traffic, the second Barrack Street Bridge also became obsolete. In 1903, consideration was given to building a horseshoe bridge, like the one built across William Street, but this was rejected on the grounds that its shape was inconvenient for traffic. An even bigger and stronger bridge replaced it in 1908. A much grander affair than its predecessors, this bridge, using Donneybrook stone and Meckering granite for its features, included cast-iron light poles. Although altered several times since, the current bridge retains many of its original 1908 features. The Old Perth Gaol building still exists but was subsumed by the Western Australian Museum (centre top) in 1891.

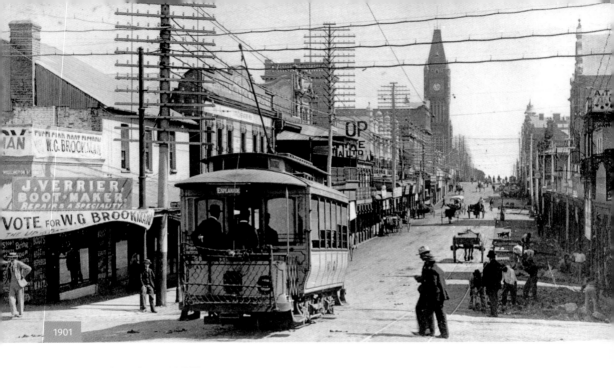

1901

BARRACK STREET

This ethnically diverse street was a major thoroughfare for trams

ABOVE: In the early 1900s Barrack Street appeared to be a sea of telephone lines. The introduction of a telephone system in 1887 brought with it a plethora of wires strung on poles down every main street in central Perth, all leading to a small manual telephone exchange in Wellington Street. Additionally, the street became one of the main thoroughfares for the trams going from a terminus on Barrack Square to the newly created suburbs of North Perth and Mount Lawley. With the convenience of the trams, Barrack Street became

an important retail centre with an ethnically diverse array of shops, including a Chinese grocer, Greek fishmonger, German butcher and the Irish-run Railway Hotel, all serving the newly developed northern suburbs. As with most views of Barrack Street, the tower of the Town Hall is the focal point of this photo. The tall building, now known as the Bon Marche Arcade, on the left near the Town Hall, was built by W.G. Brookman, who, as the banners on the left show, was campaigning to become mayor at the time of this photo.

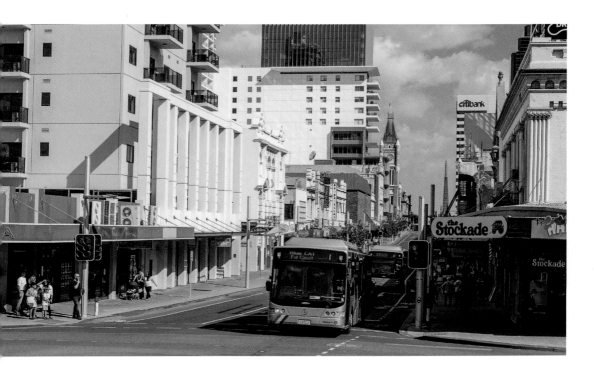

ABOVE: Taking the telephone wires underground helped to increase Barrack Street's popularity as a shopping precinct, with a popular addition to the retail outlets being the Bon Marche Arcade (the cream-coloured stucco building in front of the Town Hall), which opened in 1901. Perth radio station 6PR also started its life on Barrack Street in 1931, broadcasting from a studio above Nicholson's Music Centre (just beyond the blue-roofed building) until it moved to new studios in Hay Street after World War II. Another source of entertainment on the street was the 450-seat Liberty Theatre in a converted first floor office, which became renowned in the 1950s for screening Italian and French 'art films'. The street is still dominated by the majestic Town Hall building and remains home to many small businesses, cafés and restaurants. On the right-hand corner can be seen the Stockade Building, an exuberant example of 1910 Perth architecture.

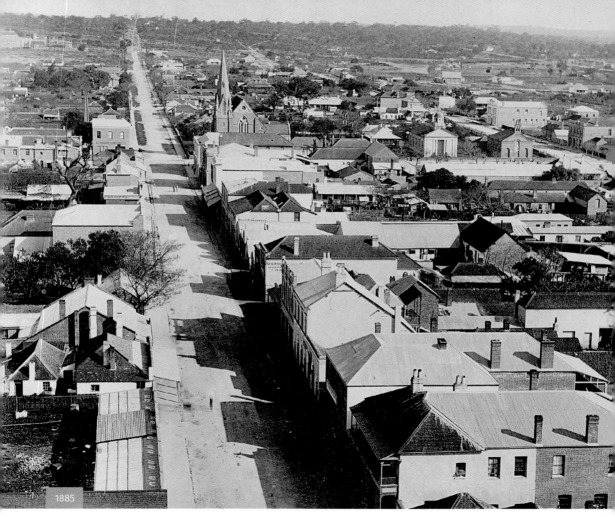

1885

TWISS STREET (HAY STREET)

The tip of Wesley Church's spire is the only thing still visible in this view

LEFT: In the early days, Perth streets seem to have been named to ingratiate British politicians. Originally Hay Street had two names: from the Town Hall eastwards it was called Howick Street, after Viscount Howick, Prime Minister of England (1830–34); while the western end was named Twiss Street, after Horace Twiss. In 1897 the entire length of the street was renamed Hay Street after Robert William Hay. To the right of Wesley Church, on William Street, can be seen the previous Methodist Church, with its small belfry perched on the roof.

RIGHT: Like St Georges Terrace, Hay Street underwent huge changes during the first gold rush. It became one of the city's principal shopping streets, with a wide variety of businesses flourishing. Prior to this time, the western end was primarily workers' cottages with shops, coal yards, smithies and foundries, but in the mid-1890s smaller businesses began to establish themselves in existing cottages and a number of larger enterprises erected substantial new offices and warehouses in the area. Now dominated by the city's multi-storey buildings, the tip of the spire of Wesley Church (barely visible in this view) is the only thing to have survived the many redevelopments Hay Street has undergone since the 1885 photograph.

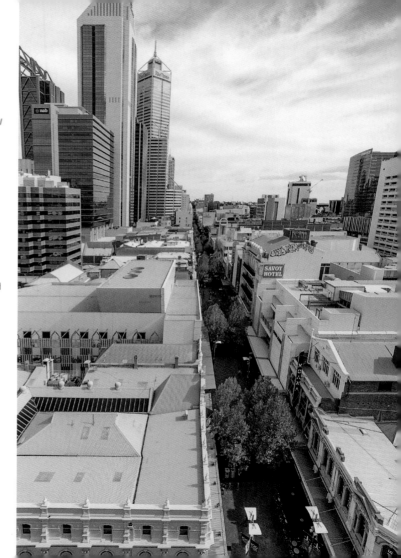

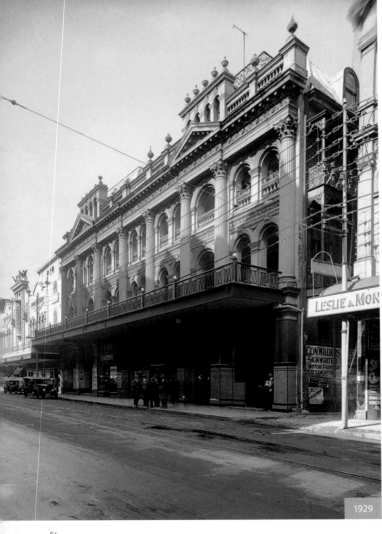

1929

THEATRE ROYAL AND HOTEL METROPOLE

Custom-built luxury on Hay Street

LEFT: The Theatre Royal was Perth's first custom-built theatre and the brain-child of Perth politician and property developer Thomas Malloy. The Hotel Metropole, which opened in 1894, was constructed first and considered to be the most luxurious hotel in Perth. The hotel occupied the right-hand side of this grand building designed in Federation Free Classical style. Once the hotel opened, plans were made for a 1,000-seat theatre next door. The foundation stone for the theatre was laid in May 1895 and when completed it included all mod-cons, such as a sliding roof in the auditorium dome and Tobin air shafts to provide ventilation 'without draughts' on hot nights. The theatre should have opened on 17 April 1897, but it was delayed by two days because the SS *Rockton*, which was transporting the actors and scenery, was caught in a storm.

RIGHT: By the middle of World War I, the Theatre Royal had been upstaged by the larger His Majesty's Theatre (also built by Malloy), further west on Hay Street. The Royal started to show films and continued with a mixed program of film and variety acts until 1934, when the lease was purchased by Perth cinema pioneer James Stiles. From then on no live acts appeared in the theatre, which focused instead on mainstream films from the major distributors of the day. The hotel was converted into a shop in 1963, with the guest accommodation transformed into storage areas. Like so many theatres and cinemas around the world in the 1970s, the Royal suffered at the hands of television and ever-dwindling audiences. The theatre screened its last film on 9 February 1978. After this the ground floor was converted into shops, with the upstairs rooms and auditorium left empty.

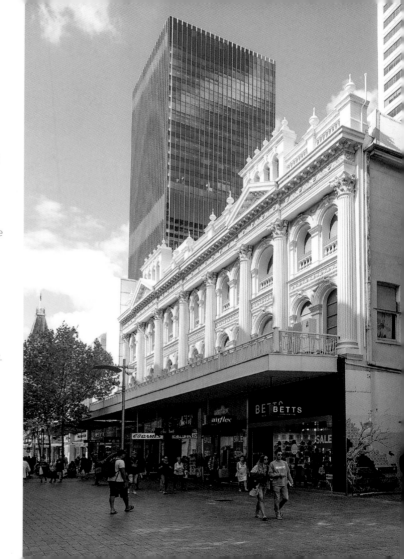

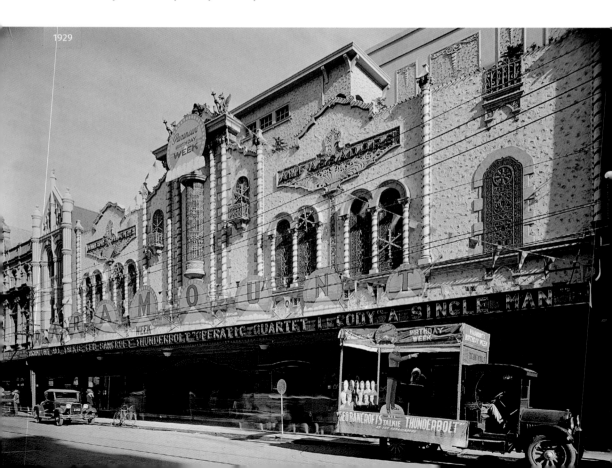

1929

LEFT: The 2,000-seat Ambassadors Theatre was probably the most extravagant cinema building Perth has ever seen. It was built in 1928 following a visit to America by the Head of Union Cinemas, Stuart Doyle, who came back besotted with the fashionable 'atmospheric' cinemas he had seen in places like San Francisco and Los Angeles. Union's architect, Henry White, adapted the American cinema style and the company proceeded to build cinemas to an 'atmospheric' design in Sydney and Perth. The theatre opened in September 1929 and immediately wooed its audience with its house orchestra and the largest Wurlitzer pipe organ in Australia.

BELOW: Not long after the theatre opened, the Wall Street Crash plunged the world into recession and the Ambassadors' audiences dwindled. The orchestra was dismissed and the theatre closed for some months in late 1932. Another change of management in 1937 heralded a radical redesign of the building, remodelling both the interior and exterior in an Art Deco style. The theatre continued as a popular venue throughout World War II and in 1953 became the first cinema in Western Australia to show a film in Cinemascope. The cinema closed in 1972 and was demolished soon afterwards to make way for a retail complex.

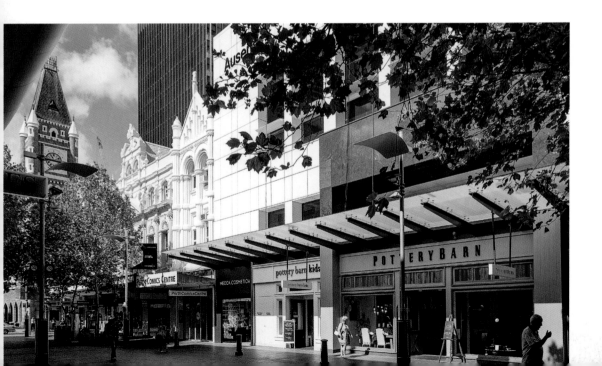

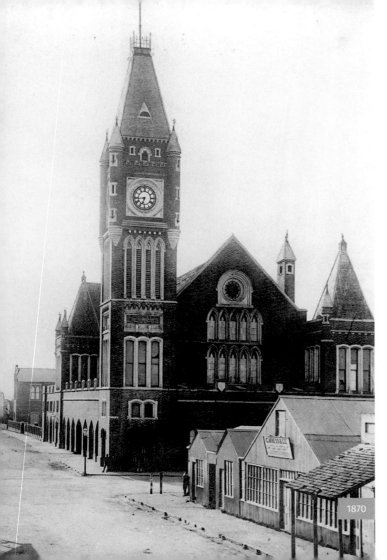

1870

PERTH TOWN HALL
The clock tower at the corner of Barrack and Hay Streets is Perth's most famous landmark

LEFT: In 1866 Governor John Hampton announced the construction of Perth Town Hall as part of a program of public works being undertaken by convict labour. The building was designed by the Supervisor of Public Works, Richard Roach Jewell, who based his Victorian Free Gothic design on the medieval town halls of Europe. Construction of the building started the following year and was expected to take 12 months to complete. Instead, it took three years, during which time the labouring convicts were thought to have added the arrow-shaped windows on the tower and decorative motifs resembling a hangman's rope. The official opening took place on Foundation Day, 1 June, 1870, when Governor Weld formally handed over responsibility for the building to the City Council.

RIGHT: A daily market was opened in the undercroft of the Town Hall in 1872, but it did not last very long as the space was felt too gloomy for a market and was put to other uses. In 1875 explorer Ernest Giles arrived in Perth following his expedition from South Australia. His camels were stabled in the undercroft while the city hosted a welcoming party upstairs. The council's first fire engine was also kept in the undercroft, but the cost of horses to pull it proved too expensive, so those from the cab rank outside were borrowed to pull the engine to a fire. Eventually the Town Hall's ground-level arches were filled in to create shops and offices, which remained until the building's restoration in 2005. On several occasions plans to redevelop the building have been suggested, but none have come to fruition and the Town Hall remains very dear to the heart of Perth's citizens. McNess's ironmongers shop, on the opposite corner of Hay and Barrack Streets, was replaced by McNess Royal Arcade in 1897. This fine building (which can be seen on the right) was Perth's first city-centre shopping arcade and remained so until it was converted into shops in the 1980s. In 2014 the facade was conserved and renovated, but at the time of writing both upper floors remain unoccupied.

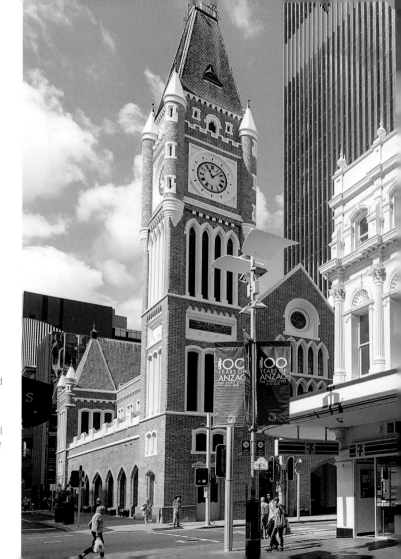

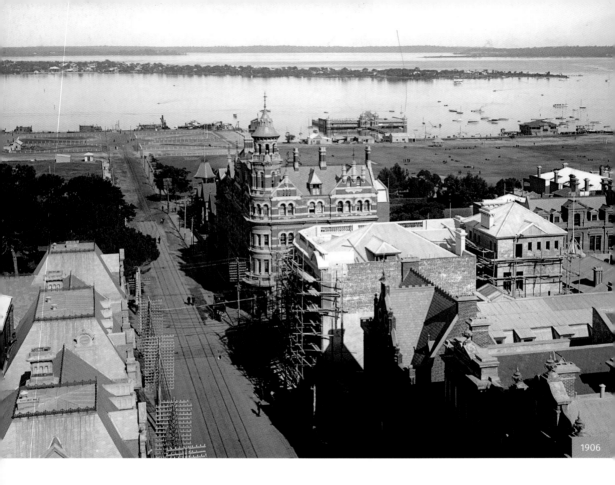

1906

BARRACK STREET LOOKING SOUTH FROM THE TOWN HALL

A number of 19th-century buildings have survived the widespread redevelopment

LEFT: Barrack Street was initially developed with housing for soldiers and officers as well as merchants' homes, warehouses and businesses. The Swan River end of Barrack Street was an important terminus for river transport and the site of a jetty from Perth's foundation. To cater for the increase in river transport and recreational needs brought about by the huge influx of people to Perth in the 1890s, several further jetties were built in conjunction with Barrack Square, which was completed in 1906 and designed to resemble a Union Jack. The onion-domed City Baths can be seen centre right and an embryonic South Perth stretches out beyond. The tall turreted building is T&G Chambers, built for the Temperance & General Life Assurance Company in 1897.

RIGHT: Since its initial construction, Barrack Square has undergone a number of changes in design, but the most major change came in 1998, when the jetties and square underwent major redevelopment, including a new ferry terminal. Centrepiece of the new-look square was the construction of Perth's iconic Bell Tower (seen at the end of Barrack Street) in 2000. Also known as Swan Bells or the Swan Tower, the glass and copper structure contains 51 bells and is open to the public daily. It is unique in being the only bell tower in the world designed to showcase the English art of change ringing. Thankfully, the Central Government Offices and the Weld Club have survived since the 1906 photograph to provide an excellent cross-section of the history of this street. T&G Chambers was demolished and replaced by Citibank House in 1962.

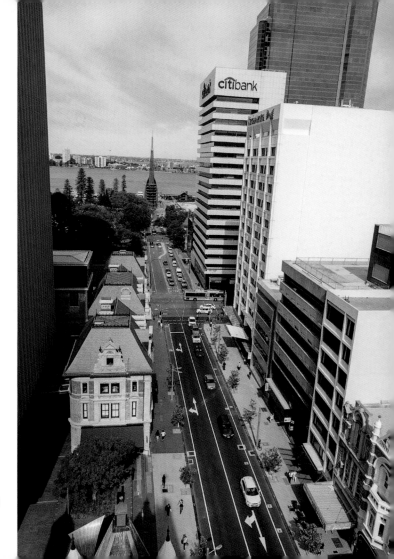

c. 1879

CENTRAL GOVERNMENT OFFICES
An architecturally significant block of 19th-century buildings

ABOVE: Incorporating part of the old Barracks Guard House, the collection of interlinking buildings along Barrack Street reflect the 19th-century practice of placing government departments in one location. The first section of what would come to be known as the Central Government Offices was built in 1874. Containing law courts and a Land Registry, it was designed by Richard Roach Jewell. Three years later, tenders were invited for the completion of the Barrack Street facade down to St Georges Terrace. The Director of Public Works described the new offices as 'having free circulation of air and commodious chambers in a building where a number of Public Officers and others are employed for many hours a day'. The commodious chambers are shown here looking up Barrack Street towards the Town Hall.

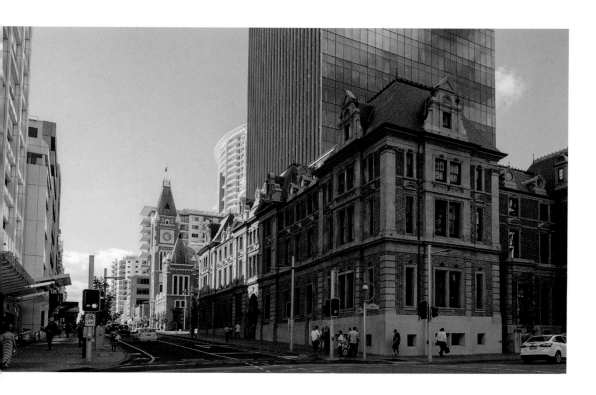

ABOVE: The next section to be constructed was the eastern wing, on the corner of Cathedral Avenue, which was completed in 1884. Two years later, the infill between this and the Barrack Street building was commenced, containing a Post Hall and Telegraph Office. Construction of this section was hampered when it was discovered that earlier work had been built on very poor foundations. A third storey was added during the 1890s to a design by George Temple-Poole, which gave the building a very French appearance. Finally, the crowning glory of the group, the Titles Office, at the northern end of Cathedral Avenue, was completed in 1897. The building continued in government use until 1996 when it was vacated. After a long period of disuse, the building has been given a new lease of life as a hotel and public plaza.

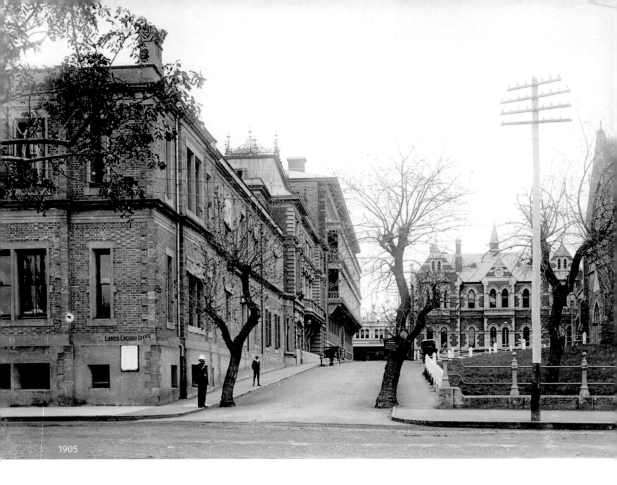

1905

ST GEORGE'S CHAMBERS
Cathedral Square is seen as the historic heart of Perth

74

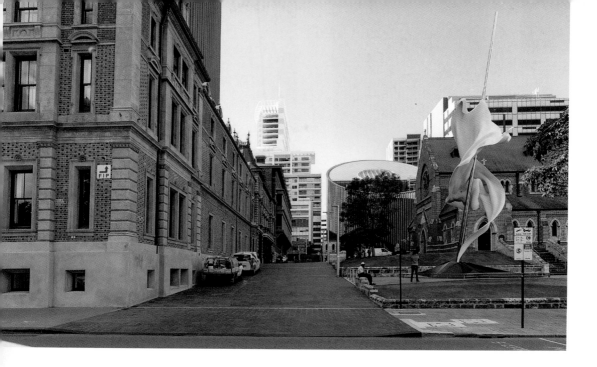

LEFT: A policeman stands in front of the Central Government Offices, with St George's Chambers on the right and the west-end of St George's Cathedral on the far right. At the furthest end of Cathedral Avenue can be seen the Bon Marche Drapery store (formerly Cargeeg Dimant & Co) on Hay Street. The first building on the site where St George's Chambers stood was the old St George's Cathedral. This building was opened as St George's Church in January 1845 and was elevated to the status of cathedral when the Anglican Diocese of Perth was formed in 1858. With the construction of a new cathedral 30 years later, the old church was demolished in 1891 and replaced by St George's Chambers.

ABOVE: St George's Chambers remained until the late 1970s when it was demolished to make way for a new Law Chambers building, which opened in 1981. Once described as Perth's 'ugliest modern building', it was partly demolished in 2012 as part of the Cathedral Square redevelopment and has since been replaced by a new Perth City Library building. Designed by local architect, the late Kerry Hill, the seven-storey, purpose-built library is the first major civic building since the construction of the Perth Concert Hall over 40 years ago. The new library, with its stone-clad columns, is a striking addition to the classical and Gothic architecture of the old Centre Government Offices and St George's Cathedral.

ST GEORGE'S CATHEDRAL
The tower was eventually added in 1902

BELOW: Despite Bishop Hale's protestations that 'there was neither sufficient money nor resources of other kinds' for the construction of a new cathedral in Perth, impetus was given to the project when Hale resigned in 1875. Four years later, work began on the present cathedral, which was designed by Sydney architect Edmund Blackett. The foundation stone was laid by the Governor, Sir William Robinson, in November 1880. The new building, which was positioned to the south and west of the old cathedral, was built of bricks made from clay dug in what is now called Queen's Gardens, with stone for trimmings quarried at Rottnest Island. The cathedral was consecrated in 1888, but funds were not sufficient to complete Blackett's design and his graceful tower and spire were omitted. St George's Chambers, which housed the diocesan offices, is on the left.

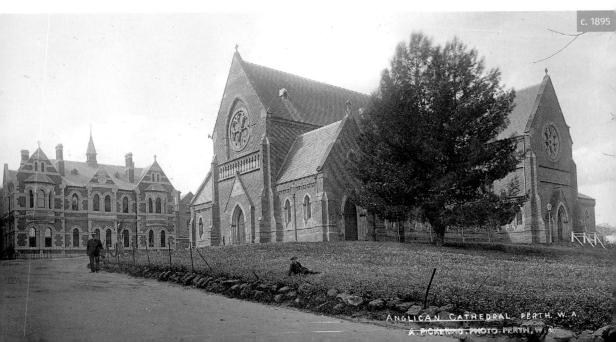
c. 1895

ANGLICAN CATHEDRAL. PERTH. W.A.
A. PICKERING. PHOTO. PERTH. W.A.

BELOW: A revised design for the cathedral's tower was eventually completed in 1902, with its ring of eight bells being cast as a memorial to Queen Victoria. The Soldiers' Memorial Chapel, which took the place of the Chapter House in the original designs, was added in 1923 in memory of Anglican members of the AIF from Western Australia who fought in World War I. The cathedral also has a wooden cross, which was made out of timbers from a ruined village as a memorial to those who fell in the battle of Villers-Bretonneux in Northern France. An extensive restoration of the cathedral, including a new slate roof and stabilisation of the tower structure, took place in 2005–2008. Outside the cathedral, an eye-catching sculpture, *Ascalon*, captures the battle of St George and the Dragon in abstract form and was officially unveiled in 2011. Perth City Library, which was completed in 2016, sits on the site of the old St George's Chambers building.

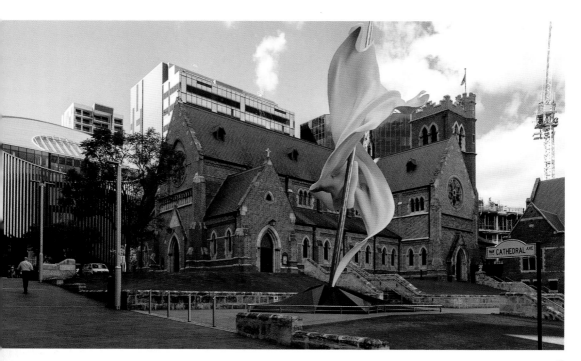

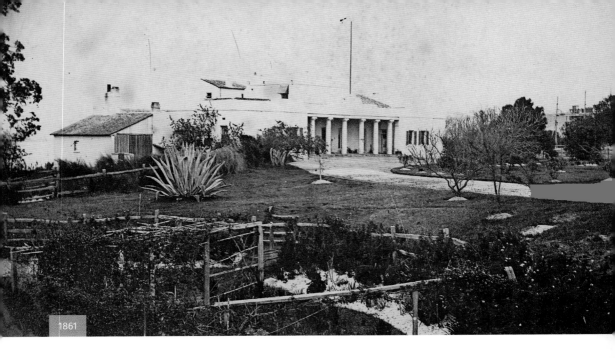

1861

GOVERNMENT HOUSE
Old Government House was an undesirable residence

ABOVE: After initially living under canvas, Governor Stirling moved into a temporary wooden building while plans were made for the first permanent vice-regal residence. After a great many problems, both political and structural, the building, designed by Perth's chief civil engineer Henry Reveley, was completed in 1837. It was described by one commentator as having 'more the appearance of a lunatic asylum than the residence of the representative of the Queen'. Aesthetic quality, however, was the least of its problems, as it proved to be a very impractical and uncomfortable house to live in. Four successive governors made do, but the arrival of Governor Arthur Kennedy in 1855 changed all that. Kennedy protested that the house was uninhabitable and approval was sought to build a replacement. The foundation stone for the new house was laid in 1859 and the building was completed in 1863 (at double the original budget), the old house being eventually demolished in the 1880s.

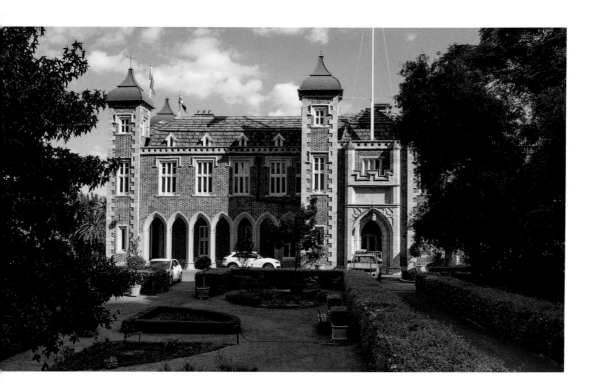

ABOVE: Sadly, Arthur Kennedy never got to live in his much wished for new residence and it was his successor, John Hampton, who became the first resident. Hampton arrived in 1862 and had a hand in many alterations to the original design. The result was a space fit for official and public entertainment – a major part of the governor's role – that included a small ballroom on the upper floor. This building served its purpose very well until the 1890s, when more space was needed for larger public gatherings. Drawings from 1897, signed by the Government Architect, John Grainger, show plans to add a new dining room and library, but these never came to fruition. However, a new ballroom and supper room were completed in 1899. Today Government House is the only one in Australia still to be on its original site, with those in other states having moved location at least once.

LANGLEY PARK
Perth's first commercial airstrip

BELOW: Langley Park was built on land reclaimed from the Swan River and was officially gazetted for the purpose of 'Parks, Gardens and Recreation' in December 1920. It is probably best known, however, as Perth's first commercial airstrip, pioneered by Major (later Sir) Norman Brearley, who used the park as his base when starting a civil aviation business in 1921. Brearley came to Perth in 1919 to give flying demonstrations to an adoring crowd. In 1920 he put a proposal to the Australian Commonwealth Government for a subsidised air mail service along the coast of Western Australia. As a result, West Australian Airways was Australia's first commercial air service, established 10 months before Qantas started operations in November 1922. This photo, taken shortly after air service commenced at Langley Park, shows Bristol Tourer biplanes belonging to West Australian Airways Ltd.

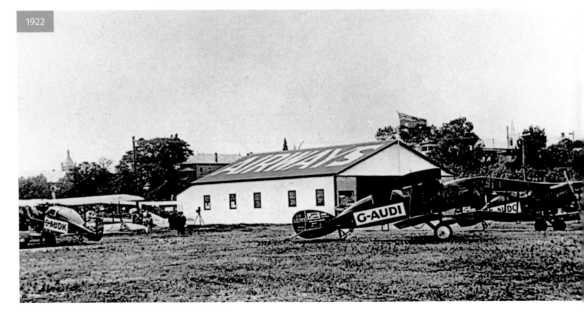

1922

BELOW: Because the park became boggy in winter, it was not an ideal location for a permanent airport and in November 1923 Brearley's operations moved to a site in Maylands. Close to the aircraft hangar was a pumping station built to improve the efficiency of the city's sewerage system. This facility, along with the rest of the system, was maintained by pump attendants, known as 'pumpies', who daily covered a circuit from Claisebrook to Subiaco on their bicycles to check operations. Named after Acting Lord Mayor, T.W. Langley, who opened the first section of Riverside Drive in 1937, the park is now a popular venue for both sporting and cultural events, particularly as a focal point for the city's Australia Day and Anzac Day commemorations. This photo is looking west towards Perth's central business district. The tallest building on the horizon is the 50-storey, 214-metre (702-foot), 108 St Georges Terrace (now South32 Tower). The small cottage-like building in the centre is a sewerage pumping station, which was decommissioned in 1989 as part of the creation of a central sewerage station.

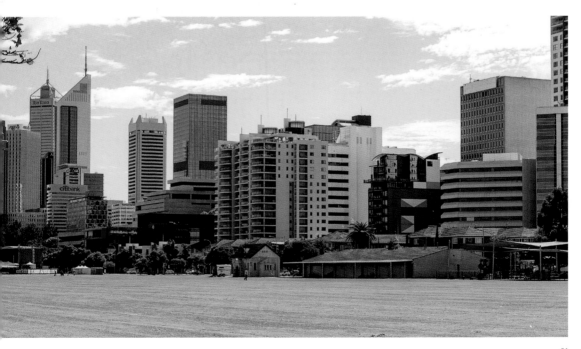

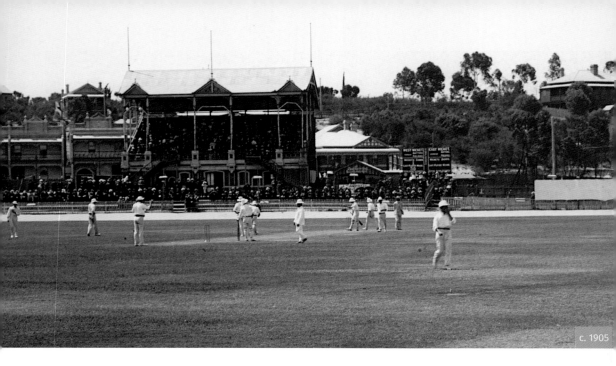

c. 1905

THE WACA
Western Australia's 'home of cricket'

ABOVE: The Western Australian Cricket Association (WACA) was established in November 1885. Soon after, it was granted a 999-year lease over 29 acres of swamp land to the east of the city on which to create a cricket ground. After the area had been drained and levelled, William Wise, gardener to the first Mayor of Perth, laid a turf wicket before the WACA Ground officially opened in 1893. The first match on the now-hallowed turf took place in February 1894. A year later, a grandstand seating 500 people was built, incorporating four dressing rooms and a dining room. Unfortunately, the beginning of the 20th century saw a period of financial instability for the Association and in 1907 the ground was under threat of being taken over by Perth City Council in settlement of debts.

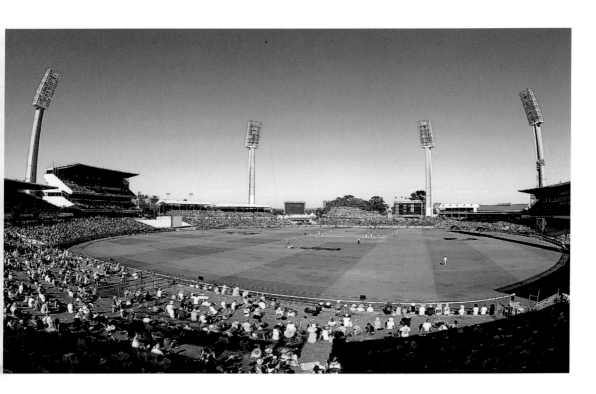

ABOVE: Further financial difficulties led the Association to raise more funds with a charity cricket match involving the Australian 1st XI in 1912 and in another bid to stabilise finances, trotting races were introduced. More excitement came in 1919, when Norman Brearley used the ground as a runway for the first flying demonstrations in Western Australia. These nearly ended in disaster when the plane almost got entangled in the electricity cables which encircled the ground. The ground's scoreboard was destroyed in a storm and replaced in 1954 with a mechanical one, which is still in use today, donated by the North West Murchison Cricket Association. With its modern concrete stands seating many thousands of people and high-intensity floodlighting, the ground appears a far cry from the halcyon days of club cricket, but Test matches at the WACA have helped to put Perth on the international map.

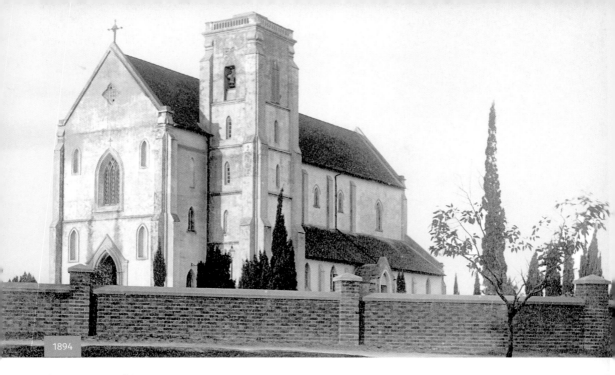

1894

ST MARY'S CATHEDRAL

The cathedral grew and changed with each stage of its construction

ABOVE: The construction of the first Roman Catholic church in Perth, St John's, started in January 1844. A year later the Catholic Diocese of Perth was formed and St John's Church was elevated to the status of cathedral. By the early 1860s the number of Roman Catholics in Perth had grown to the extent that a new and larger cathedral became necessary. This was built on a site that had originally been intended for the principal Anglican church in Perth, but was considered too far from the centre of St Georges Terrace to be practical. The foundation stone for the new cathedral, which was designed by Benedictine Oblate Brother Joseph Ascione, was laid by Bishop Rosendo Salvado in February 1863. Alas, a lack of funds retarded progress and it was not completed until 1865.

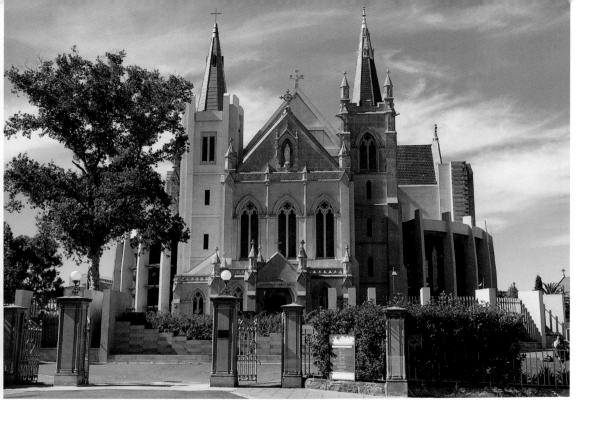

ABOVE: Between 1897 and 1905 various alterations were made to the building, including the addition of a steeple, pinnacles and gargoyles to the bell tower, a porch and electricity. In the 1920s, under the dynamic Archbishop Clune, various schemes were considered to complete the cathedral, including one by the priest-architect John Hawes for a huge Romanesque building. However, financial constraints dictated that just a new sanctuary and east end could be built and the extension was blessed by Bishop Clune in May 1930. This created a very imposing Norman Gothic building that served its community well. By the beginning of the 21st century the cathedral was again creaking at the seams and so work began in August 2006 to create a new, larger nave area in the middle of the cathedral. The newly enlarged cathedral was re-consecrated by the Archbishop of Perth in December 2009.

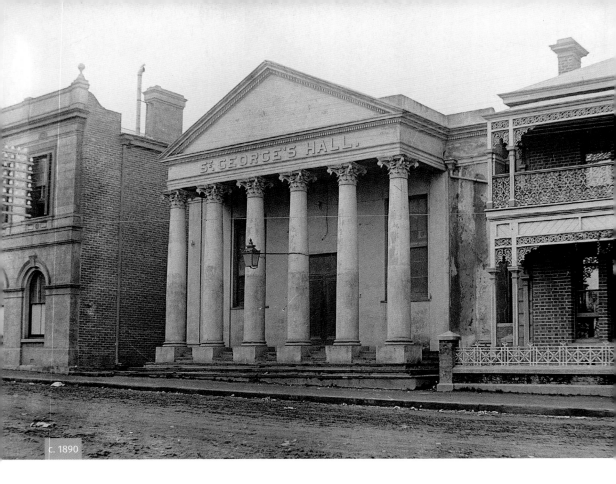

ST GEORGE'S HALL

Only the classical facade of this former theatre remains

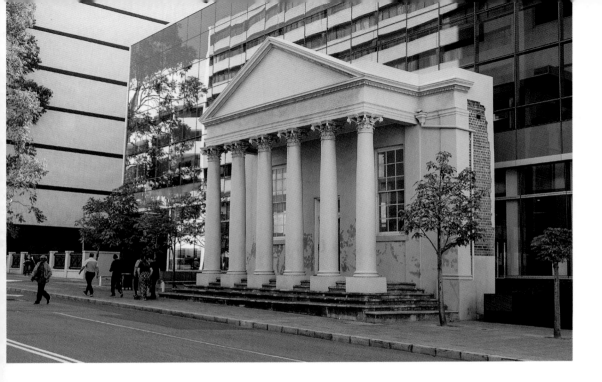

LEFT: Today it seems strange that a firm of solicitors should decide Perth needed a theatre, but it was the long-established legal firm of Stone and Burt who were the prime movers in the construction of a multi-purpose hall that could be used for theatrical productions. As a result, St George's Hall was built in 1879 with a portico said to be a copy of the Lyceum Theatre in London. The unfinished hall was first used as a public auction room in August 1879, with the official opening occurring just over a month later.

ABOVE: Until the opening of the Theatre Royal in 1897, St George's Hall was a popular venue for music and drama. For a short while in 1907 it was renamed the Sixpenny Picture Palace and used as a cinema. After this the name changed and the hall was used mainly for dances. In March 1913, the first meeting of the University of Western Australia's Convocation was held here. Soon after, the government used it for administrative purposes. Apart from the facade, the hall was demolished in 1986 to make way for a new Lands Administration office, which in turn was removed in 2004 to be replaced by a new District Court building.

ASCOT RACECOURSE

The 'grand old lady' of Australian racecourses

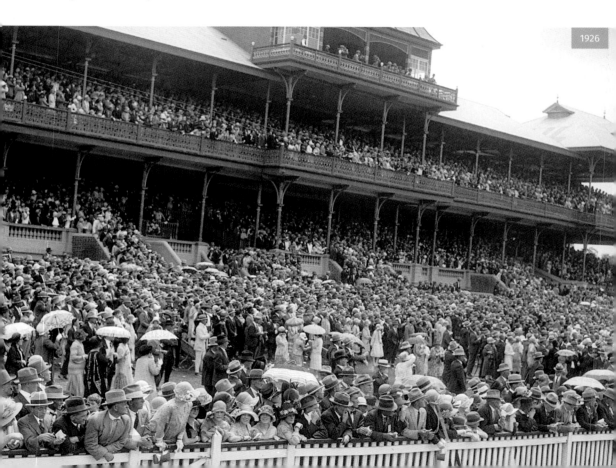

1926

LEFT: In addition to draught horses, early settlers of the Swan River Colony brought with them thoroughbreds, and the first recorded race meeting took place in Fremantle in October 1833. In 1848 a race was held on land owned by John Hardey near the Swan River, but Hardey's brother believed horse racing to be the 'gun shot of the devil', so permission for further races was withdrawn. T. R. C. Walters donated land from his adjoining property which became Ascot Racecourse, where the erection of a grandstand in 1903 brought to an end the holiday custom of picnicking on the 'flat' in the centre of the track.

BELOW: Ascot became the headquarters for horse racing in Western Australia in 1917, at which time the course was given a number of additional facilities, including a ledger stand, steward's stand and dining rooms. During World War II the racecourse was used as an army camp for American soldiers, and racing was confined to the second Saturday of the month. Parts of the original grandstand, including the cast-iron roof support columns, were incorporated into a major refurbishment and upgrading of the building, which took place in 1969. Ascot Racecourse is probably best known for the Perth Cup, which now takes place on New Year's Day.

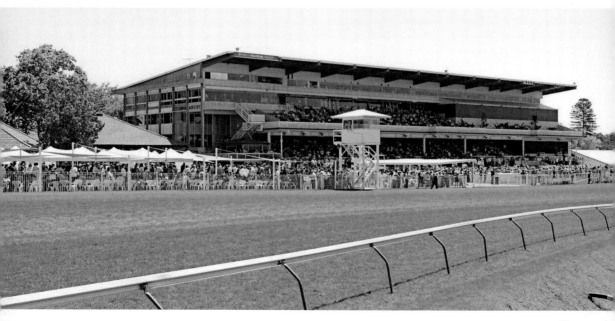

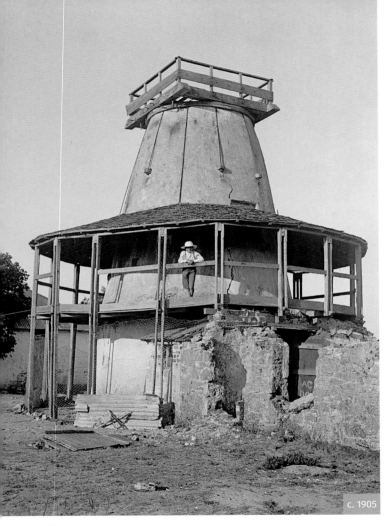

c. 1905

OLD MILL, SOUTH PERTH

Its surroundings have changed beyond recognition

LEFT: William Shenton built a windmill on Point Belches, South Perth, because of its close proximity to central Perth and ease of access to Fremantle and Guildford via the Swan River. The foundation stone for the building was laid by Governor Stirling in 1835 and two years later the mill was ready for use. At the time, the Colonial Civil Engineer, Henry Reveley, whose own water mill in Perth had failed dismally, peevishly remarked that it was 'a miserable toy, which will never do much'. Sadly, Reveley was right. A new owner converted it to steam power in the 1850s, but this was not viable either, so in 1879 a colourful South Perth resident, Thomas (Satan) Brown leased the buildings and converted them into a hotel and picnic ground called the Alta Gardens.

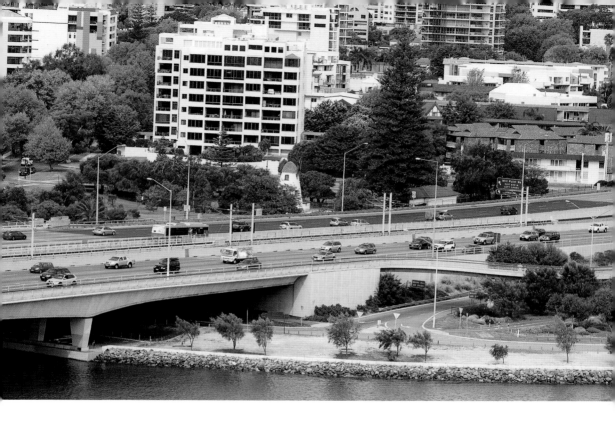

ABOVE: Thomas Brown's scheme was also a financial failure and the site was successively used as a residence, wine saloon and poultry farm until acquired by the government in 1929. In the late 1950s the Old Mill was in danger of being demolished to make way for the Kwinana Freeway, but was saved thanks to the intervention of the local community. The Old Mill and its cottage were granted to the City of South Perth to commemorate the centenary of the founding of South Perth. Fully restored, the mill became a folk museum, until passing into the care of the National Trust in 1992. In more recent times an extensive restoration has taken place, returning the Old Mill and cottage to a close approximation to their original appearance. In the view above the mill is partially obscured by the busy Kwinana Freeway taking traffic between central Perth and South Perth.

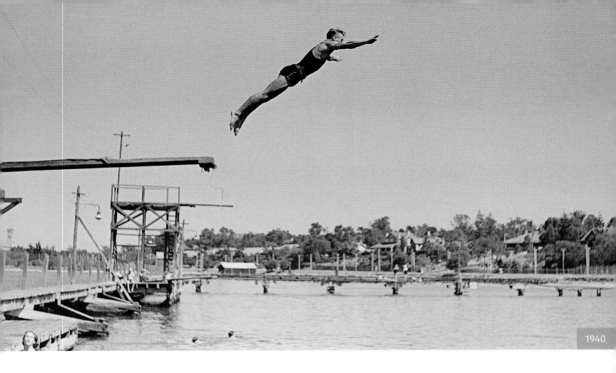

1940

CRAWLEY BATHS

A new swimming complex replaced the baths when Perth hosted the 1962 Commonwealth Games

ABOVE: Crawley Baths were built to replace the very muddy-bottomed City Baths on the Esplanade. A site on Mounts Bay Road with a sandy river bed was chosen, but being at the foot of Mount Eliza, the choice provoked much opposition. Opponents felt people on the hill's slopes would be able to look down on swimmers dressing and undressing. Ignoring this opposition, a lido was built at a cost of £5,000. The baths were opened in February 1914 by the Premier, John Scaddan, followed by a swimming carnival and life-saving display. This new facility provoked the comment, 'At last Perth has the chance to achieve greatness' from the West Australian newspaper. Said to have been the largest enclosed body of water in the Southern Hemisphere, the pool was upgraded to Olympic dimensions in 1933. This view is looking west towards houses on the lower slopes of Mount Eliza.

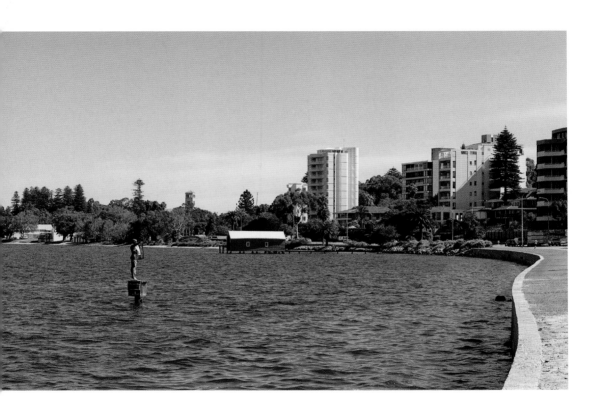

ABOVE: Countless thousands of children learnt to swim at Crawley Baths, with many having the unpleasant experience of ploughing through the large shoals of brown jellyfish which frequented the pool in warmer weather. When it was announced that the British Empire and Commonwealth Games were coming to Perth in 1962, a modern swimming complex was built at Beatty Park and Crawley Baths were demolished in 1964. To commemorate the site of the old pool (of which nothing now remains) the City of Perth commissioned Perth sculptor Tony Jones to create the figure of a woman about to dive into the water some 15 metres (49 feet) off-shore. The sculpture was unveiled in 2007, since when it has frequently been dressed in a variety of costumes to suit all occasions.

COTTESLOE BEACH
'The Brighton of the West'

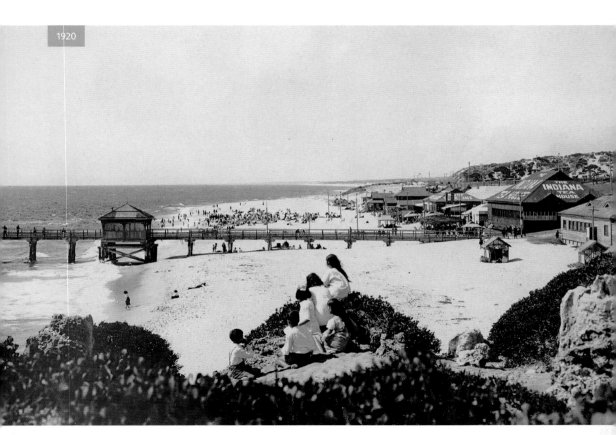

1920

LEFT: The district of Cottesloe was given its name in September 1886, in honour of Baron Cottesloe, brother of Captain C. H. Fremantle. Prior to this, the first British settler in the area was John Butler who had a 250-acre agricultural holding. With the opening of the Perth to Fremantle railway in 1881, the area became more accessible and resulted in a rush to take up land in this pleasant seaside suburb. Cottesloe became Perth's favourite beach and was further developed as ever-increasing crowds visited at weekends. This view is looking north over Cottesloe beach and includes the old Cottesloe jetty and the Indiana Tea House, which started life in 1910 as an ice-cream parlour.

BELOW: Cottesloe became known as 'the Brighton of the West', probably because of the construction of a jetty in 1906. News of the jetty spread and the beach became even more popular for sea bathing. Three concrete pylons were built to anchor a shark net following a fatal attack in 1925. Two of these were destroyed by storms and the other remains to this day as a popular marker for swimmers. Increasing maintenance problems with the jetty led to its demolition in 1952 in a spectacular gelignite explosion. The original Indiana Tea House has altered over the years and was redeveloped into its present form in 1996. Today it is a restaurant known as Indiana Cottesloe Beach.

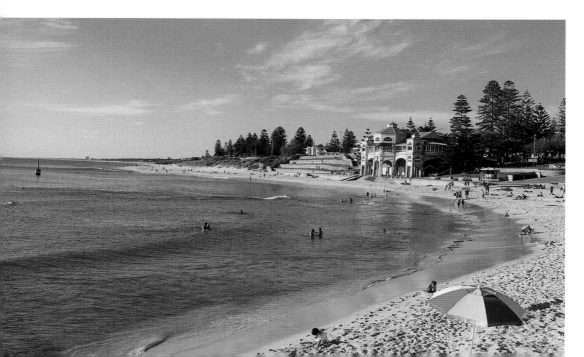

ALSO AVAILABLE **144-page Then and Nows**

ISBN 9781909815322

ISBN 9781909815315

ISBN 9781910496732

ISBN 9781910904084

ISBN 9781910904091

ISBN 9781910904794